Knowledge: Aspects of Conceptual Art

Frances Colpitt

Phyllis Plous

UNIVERSITY ART MUSEUM SANTA BARBARA

Distributed by the University of Washington Press
Seattle and London

This catalogue and the
exhibition it accompanies have
been made possible in part by
the generous support of the
Andy Warhol Foundation for the
Visual Arts, Inc., New York,
the University Museum Council
and several private donors.

Table of Contents

EXHIBITION ITINERARY

8 January – 23 February 1992
University Art Museum
Santa Barbara

2 April – 14 June 1992
Santa Monica Museum of Art
Santa Monica

8 August – 25 October 1992
North Carolina Museum of Art
Raleigh

Designed by Bollinger, Peters & Brush, Santa Barbara

Printed in an edition of 2,250 by Diamond Litho, Inc., Westlake Village

**Library of Congress
Cataloging-in Publication Data**

Plous, Phyllis.
Knowledge: Aspects of Conceptual Art/Phyllis Plous and Frances Colpitt.
p. cm.
 "Exhibition itinerary: 8 January – 23 February 1992, University Art Museum, Santa Barbara; 2 April–28 June 1992, Santa Monica Museum of Art, Santa Monica; 8 August –25 October 1992, Raleigh"—T.p. verso.
 Includes bibliographical references (p. 75).
 ISBN 0-942006-22-4 (pbk.)
 1. Conceptual art—United States—Exhibition. 2. Art Modern—20th century—United States—Exhibitions. 3. Conceptual art—Exhibitions. 4. Art, Modern—20th century—Exhibitions.
I. Colpitt, Frances. II. University of California, Santa Barbara. University Art Museum. III. Santa Monica Museum of Art. IV. North Carolina Museum of Art. V. Title. N6512.5.C64P56 1992
709'.73'07473—dc20 92-740
 CIP

Certain photographs reproduced in this book are subject to copyrights noted in the photography credits.

Cover: Mike Kelley *Know Nothing/If You Don't Want to Know the Definition, Don't Open the Dictionary*, 1982 – 1983 (detail)

Foreword

There is a symmetry of interests in a university art museum organizing an exhibition that presents work whose subject is ideas. It is even more fitting that the project's title be *Knowledge,* a complex intangible that is implicit in all educational programs.

There are intriguing parallels between the goals and histories of Conceptualism and Academia over the past twenty-five years. Conceptualism emerged in the late sixties as a reaction against the canons of modernism and the formalist dogma of Clement Greenberg. Artists were searching for radically alternative modes of expression. At the same time, vigorous protests were occurring on college and university campuses in the United States and Europe. Repudiation of the establishment and its call to war, combined with the search for different truths and alternative models of understanding, infused higher education with renewed energy. During this period, the art and academic worlds were catapulted into radical reexaminations of their methods, definitions, and priorities. Responses to these developments were mixed and sometimes reactionary. Yet, provocation and controversy have long driven the search for knowledge within and beyond both Conceptualism and Academia. Both continue to be fueled by the expansion and enrichment of critical modes of inquiry and analysis.

Congratulations and thanks are due Phyllis Plous, the University Art Museum's Curator of Twentieth Century Art, and her Co-curator, Frances Colpitt (University of Texas, San Antonio), for gathering a body of work that so effectively traces and reveals Conceptualism's history. *Knowledge* is especially meaningful because it is a culmination of Plous's long career of introducing exciting and innovative forms of contemporary artistic expression to the University Art Museum and to the venues where such shows have traveled. Through the exhibition and catalogue both curators challenge us to discover the knowledge embedded in Conceptualism's messages. It is not an exhibition for those who seek easy answers; like an educational process, it asks its participants to give and not only receive.

The University Art Museum is grateful to The Andy Warhol Foundation for the Visual Arts, Inc., the University Museum Council and several private donors for their essential contributions. Without the generosity of many lenders, the exhibition would not have been possible. The Museum staff is to be commended for its fine support and assistance in bringing this complex project to fruition: Herbert M. Cole (former Acting Director); Rollin Fortier, Preparator; Corinne Gillet-Horowitz, Education Curator; Sharon Major, Public Relations; Judy McKee, Administrative Assistant; Julie Osterling, Curatorial Assistant; Paul Prince, Exhibitions Designer; Sandra Rushing, Registrar; and Gary Todd, Secretary.

Marla C. Berns
Director

Lenders

John Baldessari

Robert Barry

The Bohen Foundation

Roy Boyd Gallery, Santa Monica

Rena G. Bransten

Leo Castelli Gallery, New York

The Chase Manhattan Bank, N.A.

Douglas S. Cramer

Nancy and Ray Fisher

Marian Goodman Gallery, New York

Jay Gorney Modern Art, New York

Galerie Max Hetzler, Cologne

Douglas Huebler

Richard Kuhlenschmidt Gallery
Santa Monica

Louise Lawler

Margo Leavin Gallery, Los Angeles

Lisson Gallery, London

Mary and Robert Looker

Metro Pictures, New York

Milwaukee Art Museum

The Panza Collection

The Praxis Collection

Charles Perliter and Ellen Grinstein Perliter

Julian Pretto Gallery, New York

Private Collection, Courtesy Rosamund
Felsen Gallery, Los Angeles

Private Collection, Courtesy Thea Westreich
New York

Holly Solomon Gallery, New York

Thomas Solomon's Garage, Los Angeles

The Sonnabend Collection

Sonnabend Gallery, New York

Dorothy and Herbert Vogel

John Weber Gallery, New York

Whitney Museum of American Art, New York

Acknowledgments

One of the particular pleasures of being a curator is that of exhibiting the work of living artists who are old friends as well as new found ones. Especially vital to the achievement of this exhibition's purpose are the eighteen artists selected to participate in it. For the insights they shared with co-curator Frances Colpitt and myself during studio visits, I am deeply grateful.

The proposal for the exhibition was generated during several conversations with Frances Colpitt, critic and art historian at the University of Texas, San Antonio. A well-known scholar in the field, she has been an invigorating and supportive partner in selecting the art and organizing the myriad aspects of the exhibition and its catalogue. In 1989 the University Art Museum's Collections and Exhibition Committee, especially the late Steven Cortright who had collaborated with me on the 1975 *Visual/Verbal* show, welcomed and affirmed our proposal. My special appreciation is extended to the Andy Warhol Foundation for the Visual Arts, Inc., New York, the University Museum Council and several private donors who subsequently provided generous funds because of their confidence in the Museum and its contemporary program.

With immense gratitude I want to draw attention to the many lenders who agreed to part with their works temporarily, understanding the need to explore the changes Conceptual Art has wrought in bringing art and lived experience closer together. For their active participation in arranging the tour of the exhibition to the Santa Monica Museum of Art and the North Carolina Museum of Art, I wish to thank Thomas Rhoads, Director, and Karen Moss, Consulting Curator, in Santa Monica and John W. Coffey, Curator of American and Modern Art, Raleigh.

Several individuals assisted in smoothing out problems: Dean Sobel, Associate Curator, Milwaukee Art Museum; Paula Waxman, Curator, the Douglas S. Cramer Foundation; Caroline Cros, the Bohen Foundation; Elyse Grinstein and Robert Livernois. For obtaining necessary materials and providing arrangements, we are indebted to the artists' commercial representatives: in New York, Antonio Homem and Stefano Basilico, co-directors, Sonnabend Gallery; Mary Jo Marks, Leo Castelli Gallery; Jill Sussman, Marian Goodman Gallery; Jay Gorney and Richard Whitesell, Jay Gorney Modern Art; David Goldsmith, Jacqueline Brustein and Thomas Lyons, Metro Pictures; Julian Pretto and his staff; Lawrence Shopmaker, director, Max Protetch Gallery; Elyse Greenberg, co-director, John Weber Gallery; Richard Flood,

Acknowledgments (continued)

director, and Alexis Summer, Barbara Gladstone Gallery; in London, Diane Delvaulx, Lisson Gallery; in Los Angeles, Rosamund Felsen and her staff; Margo Leavin, Wendy Brandow and Lynn Sharpless, Margo Leavin Gallery; Stuart Regen and Shaun Caley, Stuart Regen Gallery; and Tom Solomon, Thomas Solomon's Garage; in Santa Monica, Richard Telles, director and Jody Zellen, Roy Boyd Gallery; Richard Kuhlenschmidt and his staff; and Mia Von Sadovszky, director, Luhring Augustine Hetzler. There are always individuals who make less visible but invaluable contributions: Robert Looker led me to areas of related reading in other fields; Mary Looker, the indefatigable heart of the University Museum Council, provided countless avenues of assistance, large and small; Don Walton devised a computerized graphic representation of the exhibition's proposed installation, allowing us to "see" the exhibition before it occurred.

For their essential participation in arrangements, I wish to thank the Museum's staff: in particular Marla C. Berns, our newly appointed director, and Rollin Fortier, Corinne Gillet-Horowitz, Sandra Rushing, Sharon Major, Judy McKee and Gary Todd. Julie Osterling, my assistant, ably attended to the checklist, biographical and bibliographical materials for the catalogue and made sense of its manuscripts through many transformations. I am very grateful to her for all her good work. My warm thanks and admiration go to Paul Prince, exhibition designer, with whom I have worked these past sixteen years, for his enduring excellence in spatial design. *PBP*.

Preface

Although the context of the present exhibition of Conceptual Art emphasizes the interest of Conceptual artists in aspects of knowing and the evaluation of meaning, Conceptualism also has had concrete concerns internal to the art scene. Conceptual Art and its descendants have both reflected and contributed to the aesthetic controversies of the last few decades, and they have affected and been affected by other art movements. The intention of the exhibition is to examine this ongoing construct of late twentieth-century art, one in which the philosophical substructure of art-making, the nature of what is meant by individual works or projects, and the roles of artist and viewer have been questioned and in many instances reinvented.

The exhibition's interest is to identify both the threads of continuity and the differences in motivation between Conceptualists of the sixties (most of whom remain contemporary by dint of their ability to respond and contribute to cultural change), and Conceptually-based artists from the seventies until now.

Given the modest space of our galleries, the selection of artists cannot possibly provide an exhaustive representation of Conceptual Art's enormous sweep and influence. This attempt to examine the strategies and apparatus of Conceptualism from 1965 to now is meant to be open-ended and to involve the viewer/reader. For the passive, a caveat is offered. *PBP*.

ONE KILOGRAM OF LACQUER POURED UPON A FLOOR

Lawrence Weiner
ONE KILOGRAM OF LACQUER POURED UPON A FLOOR 1969

Past and Present Moments of Conceptual Art: The Breadth of Knowledge

Frances Colpitt

Conceptual Art celebrates the cognitive. It finds pleasure and complexity in thought. Although the subjects of Conceptual Art are many and varied, much of it deals explicitly with knowledge, an aspect considered essential to art prior to the modern period. In the early nineteenth century, Schopenhauer claimed that "every work of art accordingly really aims at showing us life and things as they are in truth," at "the facilitating of the knowledge of the Ideas of the world."[1] Conceptual Art reasserts the centrality of knowledge. It returns to "the Ideas of the world."

Conceptual Art, which originated in the mid-sixties, was a reaction to formalism, a position developed primarily by the critic Clement Greenberg. Greenberg held that modern art was self-critical, that painting was about the stuff of painting, i.e., the medium and the support (what Joseph Kosuth called its "morphology"), and that it therefore necessarily strove toward flatness and rejected what was not essential to it, such as literary ideas. This position is predicated on early twentieth century criticism, especially Clive Bell's concept of significant form, which intended to show that it was not *mimesis* that interested modern painters so much as color, composition and space. In 1917, Roger Fry explained: "With the new indifference to representation we have become much less interested in skill and not at all interested in knowledge."[2] Formalism foregrounds the contemplative nature of art at the expense of the cognitive. Critical of Greenberg's promotion of painters such as Morris Louis, Kenneth Noland and Jules Olitski, Conceptualism echoed Marcel Duchamp's rejection of "retinal" painting, which appeals to the eye alone. "'All through the last half of the nineteenth century in France there was an expression, *bête comme un peintre,*' Duchamp has said. 'And it was true; that kind of painter *is* stupid.'"[3] At the other end of modernism, in 1975, Art & Language's Mel Ramsden quipped of the most refined and sensual of abstract art, "Brice Marden's paintings are kinda dumb."[4]

Heralding the Conceptual enterprise, in 1967, Sol LeWitt announced that "It is the objective of the artist who is concerned with conceptual art to make his work mentally interesting to the spectator."[5] Sixties Conceptualism rejected the sensual appeal of color, composition and space, and returned to concerns with the mind's apperception of reality. The world, and how we know it, are posited as once again of interest.

Although Conceptual Art appeared to be submerged under the diffusion of Pluralism and the anti-intellectualism of Neo-Expressionism in the late seventies and early eighties, it never really went away.[6] With formalism safely displaced, a younger generation of artists has been motivated by the postmodern critiques of representation as a construction of knowledge and the institutional nature of art. Just like their predecessors, they have used the tools of photography and language to articulate issues of meaning. As a testament to the existence of the idea or event it records, the Conceptual photograph is a document rather than a formalist exercise in artful composition. Language, too, comes to the forefront because Conceptual Art traffics in ideas; and ideas are most clearly formulated and expressed in words. Words and pictures are used to explore the relationship of knowledge to the facts of reality.

Although radically antiformal, Conceptual Art, like the modernist project in general, originated in a questioning of the nature and definition of art itself. For the British group Art & Language, "None of the concepts [of art] capture anything *natural* to the practice of art because nothing is natural to that practice—rather they are merely *conventions* adopted by artists as if they were natural. None of them are essential, they are all expendable."[7] Shortly after the founders of Art & Language, Terry Atkinson and Michael Baldwin, met in 1966, they began to have "conversations" about art. Eventually, "the 'talk' went up on the wall."[8] The

name Art & Language was registered as a partnership business in 1968, and *Art-Language: The Journal of Conceptual Art* appeared the following year, edited by Atkinson, Baldwin, David Bainbridge and Harold Hurrell.[9] In the first issue, Atkinson asked, "Can this editorial, in itself an attempt to evince some outlines as to what 'conceptual art' is, come up for the count as a work of conceptual art?" Influenced by Ludwig Wittgenstein's philosophy, as many artists were in the sixties, Atkinson's point depends on Wittgenstein's assertion that "the meaning is the use."[10] As works of art themselves, the articles in *Art-Language* verbally investigate the theory and structure of art, placing their art, according to Victor Burgin, "entirely within the linguistic infrastructure which previously served merely to support art."[11] Work by Art & Language became its own criticism, which explains why their work is so resistant to interpretation. By the late seventies, the group had reformed, and seeking "alternatives for critical inquiry," they "arranged an accident for the work."[12] Since they believed that there was nothing natural to the class of art, painting provided another, and at this point, highly suspect language in which to converse. Like the written work, the paintings flirt with the possibilities of misreading. Illegibility is an attribute of the stylized letters

s-u-r-f in the *Hostage Drawings,* "an abbreviation, conceivably, for 'surface.' It's also an abbreviation for nothing; it's a Boojum word."[13] The emphasis on the material surface of painting to the exclusion of illusion is characteristically modern; and it is the monolithic and autonomous modern that Art & Language seeks to destabilize.

In 1966, artist and critic Mel Bochner organized the first exhibition of Conceptual Art, *Working Drawings and Other Visible Things on Paper,* at the School of Visual Arts Gallery in New York. As a student of Bochner's,[14] Joseph Kosuth made his first Conceptual work in 1965, *Clear, Square, Glass, Leaning*: four sheets of glass, each lettered with a word from the title. The square, repetitive nature of the work owes a lot to Minimalism and Donald Judd in particular, whom Kosuth acknowledges in his essay "Art After Philosophy." The colorlessness of glass led Kosuth to the idea of defining water, which led in turn to his *First Investigations,* black and white photostatic enlargements of dictionary definitions, as part of his Art as Idea as Idea program. The idea, Kosuth explained, is art as idea,[15] and is derived from Ad Reinhardt's Art as Art dogma: "There is just one aesthetics, just one art idea, one meaning, just one principle, one force."[16] Reinhardt's *Black Paintings* of 1960-66 also influenced Art & Language's black monochrome

squares,[17] which illustrate their commitment to abstraction "not as the visual characteristic of a range of objects... but as a faculty of thought."[18]

Kosuth's *One and Three Hammers*, 1965, from the *Proto-Investigation Series*, presents three forms of knowing an object: through its picture, its material form and its definition in the dictionary. The *Proto-Investigations* were conceived before the *First Investigations* but not made until later, which has resulted in controversy over their dates.[19] Equally controversial was Kosuth's "Art After Philosophy." Essentially a manifesto of Conceptual Art, the three-part essay contends that, in its analysis of meaning, art has replaced philosophy.[20] The formalist definition of art on morphological grounds (a work of art is, "e.g., a rectangular-shaped canvas stretched over wooden supports and stained with such and such colors") is rejected because it fails to question the nature of art itself. Wittgenstein's discussion of tautological propositions led Kosuth to posit that "the 'art idea' (or 'work') and art are the same and can be appreciated as art without going outside the context of art for verification." By the end of the next decade, however, Kosuth had opened up his concerns to the larger cultural sphere, previously unacknowledged by his work. In 1978, in the window of the Carmen Lamanna Gallery in

Toronto, his large, printed poster declared:

What is this before you? You could say that it is a text, words on a window. But already at this point this text begins to assume more, mean more, than simply what is said here. Even if this text would only want to talk about itself, it would still have to leave itself, and have you look past it, into that gallery space beyond it which frames it and gives it meaning.

Kosuth was included in the landmark Conceptual exhibition *January 5-31, 1969,* along with Robert Barry, Douglas Huebler and Lawrence Weiner.[21] The show was organized by New York art dealer Seth Siegelaub, who had been in the gallery business since 1964, and had shown

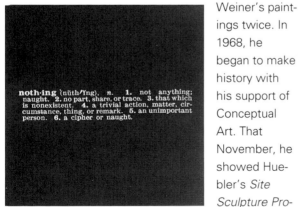

Joseph Kosuth
Art as Idea as Idea: Nothing 1967
First Investigation Series
(detail)

Weiner's paintings twice. In 1968, he began to make history with his support of Conceptual Art. That November, he showed Huebler's *Site Sculpture Projects,* which connect points on maps to form geometric configurations. *Variable Piece #1,* 1968, for example, indicates the placement of small stickers on buildings, street corners and vehicles located at the corners of concentric squares drawn on a map of Manhattan. As spatiotemporal

paradoxes, impossible to perceive in one time and place, the works in Huebler's exhibition were presented solely in the form of a catalogue printed by Siegelaub.[22]

As it was articulated by Siegelaub, Conceptual Art had a specifically political dimension. While reproductions of painting and sculpture can only provide what he called "secondary information," the Conceptual text or photograph "is not altered by its presentation in printed media." As primary information, losing nothing in reproduction, it can just as well be distributed through books and catalogues.[23] For Siegelaub, who is "concerned with getting art out in the world," primary information can reach a wider audience and avoid, to an extent, the commodification and commercialization of the art object.[24]

In 1968, Siegelaub organized an exhibition of work by Barry, Weiner and Carl Andre at Bradford Junior College in Massachusetts, where Huebler was a teacher and Sarah Charlesworth a student.[25] Andre, a Minimalist, was one of the earliest to articulate the significance of place in contemporary art, by proposing an alternative to the delimited object in his outline of the development of modern sculpture:

Sculpture as form
Sculpture as structure
Sculpture as place.[26]

Weiner's *Cratering Pieces,* made

with explosives in Mill Valley, California in 1960, seem to predict the low-lying, antimonolithic sculptures of Andre. At Bradford, Weiner showed the *Removal Series,* rectangular paintings with notches cut from the corners. In a sequel exhibition at Windham College in Vermont, Weiner continued to remove material, but expanded the space involved for an outdoor 70' x 100' grid of stakes and twine, with a 10' x 20' notch removed. Shortly afterward, Weiner began to present his work in words, which may or may not be realized in actual matter (e.g., *ONE KILOGRAM OF LACQUER POURED UPON A FLOOR,* 1969). Whether the phrase is executed or not, the words conjure up place and materiality, which are linguistically specified but indeterminate.

Robert Barry's work is a model of reduction from the visible to the invisible. At the Windham College exhibition, he stretched nearly imperceptible nylon cords between buildings, which led him to discard "the idea that art was necessarily something to look at."[27] This was brought to fruition in his use of radio waves for the *Carrier Wave Pieces* of 1968, and of invisible gases released around Los Angeles in 1969 in the *Inert Gas Series.* Pure thought is the subject of the *Psychic Series.* Presented in 1969, *Everything in the unconscious perceived by the senses but not*

noted by the conscious mind during trips to Baltimore, during the summer of 1967, radically assumes that art can exist without material form. ALL THE THINGS I KNOW BUT OF WHICH I AM NOT AT THE MOMENT THINKING..., 1969, continues to locate the work in the mind of the artist, while Telepathic Piece, 1969, transfers the work of art to the receiver. Substituting the spoken for the written word, Barry's Sound Pieces pervade the space in which they are presented in a manner similar to their inspiration: the artist's experience of listening to Gregorian chants in The Cloisters in New York. The two voices which read Barry's evocative words pause, as if a page were being turned, and drift into the mind of the perceiver who, according to Barry, completes the piece.[28]

Inasmuch as the idea is available to any perceiver for the taking, works of Conceptual Art are "priceless" multiples. Barry's contribution to the exhibition Prospect '69 in Düsseldorf consisted of the ideas in the minds of people who read an interview about the idea for the piece. Asked if the work exists, Barry replied, "It does exist if you have any ideas about it, and that part is yours. The rest you can only

2. ROBERT BARRY

Telepathic Piece, 1969

[During the Exhibition I will try to communicate telepathically a work of art, the nature of which is a series of thoughts that are not applicable to language or image.]

Robert Barry
Telepathic Piece
1969
(detail)

imagine." According to Weiner, "Once you know about a work of mine, you own it. There's no way I can climb into somebody's head and remove it."[29] Weiner's work always includes the following directive:

1. The artist may construct the piece
2. The piece may be fabricated
3. The piece need not be built
Each being equal and consistent with the intent of the artist the decision as to condition rests with the receiver upon the occasion of receivership.

Weiner's A TRANSLATION FROM ONE LANGUAGE TO ANOTHER of 1969 provided the starting point for Stephen Prina's 1989 Upon the Occasion of Receivership. Prina configured himself as the receiver, and employed Berlitz Translation Services to translate Weiner's phrase into sixty different languages. Each translation was neatly typed on a sheet of Berlitz letterhead. That the value of Conceptual Art lies not in the material object but in the idea is made explicit in Louise Lawler's matchbooks, which were printed in batches with quotes or exhibition information and given away.

"The world is full of objects, more or less interesting; I do not wish to add any more," Huebler wrote in the catalogue of Siegelaub's January 5–31, 1969 show. [30] The year before, Lucy Lippard and John Chandler speculated that the object may become obsolete, "dematerialized." Critic Gordon Brown confirmed "The Dematerialization of the Object"

in Arts Magazine later that year; and Ursula Meyer seconded it in "De-Objectification of the Object."[31] The argument for dematerialization was based not only on Conceptual innovations, but on the collapse of traditional distinctions of painting and sculpture in Minimalism and on Process Art's rejection of the bounded, discrete shape. The Conceptualists' presentation of photographs, maps and written texts as conveyors of art ideas rather than art objects in themselves emphasized meaning over appearance. Kosuth voiced his concerns about the Art as Idea as Idea definitions:

I always considered the photostat the work's form of presentation (or media); but I never wanted anyone to think that I was presenting a photostat as a work of art.... The idea with the photostat was that they could be thrown away and then re-made—if need be—as part of an irrelevant procedure connected with the form of presentation, but not with the "art."[32]

Art which appeared only in catalogues, telegrams and Xerox books was multiple, without discrete form and uncommodified. Barry's Psychic Series and Ian Wilson's "oral communication" (talking as an art form) finalized the dematerialization of the art object. This only confirmed the apparent inevitability of the modernist reduction, the progressive elimination of pictorial space, figuration, gesture and facture to arrive, finally, at the essence of art.

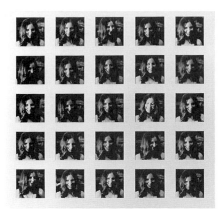

Douglas Huebler
Variable Piece No. 116
1973 (detail)

Around 1970, dematerialization was widely accepted as the explanation and justification of Conceptual Art. But there were dissenting voices. In response to Lippard and Chandler, Art & Language wrote:

All the examples of art-works (ideas) you refer to in your article are, with few exceptions, art-objects. They may not be an art-object as we know it in its traditional matter-state, but they are nevertheless matter in one of its forms, either solid-state, gas-state, liquid-state.... Consequently, when you point, among other things, to an object made by Atkinson, "Map to not indicate etc.," that it has "almost entirely eliminated the visual-physical element," I am a little apprehensive of such a description. The map is just as much a solid-state object (i.e., paper with ink lines upon it) as is any Rubens (stretcher-canvas with paint upon it) and as such comes up for the count of being just as physically-visually perusable as the Rubens.[33]

The question was raised as to whether words are objects. Lizzie Borden maintained that "there can be no absolute dematerialization because words are also cultural 'objects' to which the senses give signification."[34] Even without material form, language can be an object; and it seems unthinkable not to describe maps and photographs as objects. Recent critics now consider dematerialization a myth.[35] Nevertheless, it was a useful myth, assumed as a truth by many artists and critics at the time, and its currency must be respected. Those who held to it believed that the art did not reside

in the material thing, but in the intangible idea, which would continue to exist even if the package—the object—were destroyed or never made.

Situating herself within the Conceptual tradition, but troubled by the myth of dematerialization, Sarah Charlesworth was the first artist to formulate a way out of the dilemma. "To the extent that conceptual art is dependent upon the very same mechanisms for presentation, dissemination, and interpretation of art works," she wrote, "it *functions in society* in a manner not unlike more morphologically oriented work. [It] moves in the world of commodity-products and hardly the realm of 'idea.'"[36] Rather than be content with abstract dictionary definitions, Charlesworth focused on political events, suicides and, more recently, on seduction. Where early Conceptualists refused to consider the potency of the object, believing that it was only a document and nothing more, she realized that the nature of the object reinforces the idea. To make a work about seduction, she makes the work seductive.[37] Compare, for example, *Lotus Bowl*, 1986, with Huebler's *Variable Piece No. 116*, 1973, based on his intent, stated in many of his works, to "photographically document, to the extent of his capacity, the existence of everyone alive," and for which the subject, Meredith Palmer, was "instructed

to keep a straight face," while the artist softly whistled in her ear and blew on her neck. Huebler's work is *about* seduction, yet is anything but seductive, while Charlesworth's is desirable on a sensual as well as intellectual level.

In the 1970s, Conceptual Art flourished at the California Institute of the Arts, where Huebler was an influential member of the faculty, especially for Mike Kelley. The art department was organized by Paul Brach and John Baldessari, who brought Kosuth and Weiner as visiting artists. Prina and Christopher Williams were students there in the late seventies when they encountered another instrumental instructor, Michael Asher, an important link between early Conceptualism and the present. Originally identified with the Light and Space movement in Los Angeles, Asher painted walls and fine-tuned spaces rather than made objects. His 1974 exhibition at the Claire Copley Gallery in Los Angeles, although received by critics at the time as perceptual in intent, was a prophetic acknowledgement of the institutional nature of art. Asher removed an interior wall between the exhibition space and Copley's office, revealing to every visitor the business of art, the market system on which the art world thrives. Ostensibly similar to Weiner's 1968 *A 36" X 36" REMOVAL TO THE LATHING OR SUPPORT WALL OF PLASTER*

OR WALLBOARD FROM A WALL, Asher initiates a broader political critique.

Louise Lawler also draws our attention to the dynamics of the very space we often overlook, the place where art exists and is beheld. She has investigated and codified artworld management and distribution systems through the use of letterheads, invitations and matchbooks, as well as the installation and arrangement of pictures. Since 1982, she has not only taken on the photographic documentation of the display of works of art, but has directly participated in selecting and arranging works by other artists. She has created

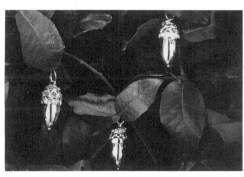

Richard Prince
Untitled (jewelry against nature)
1978–1979

exhibitions from the permanent collections of the Wadsworth Atheneum and the Boston Museum of Fine Arts, while the Isabella Stewart Gardner Museum in Boston is the site of her reframing of Renaissance paintings by Raphael and Bellini. Photographs of the paintings on display are framed by mats which read *Does it matter who owns it?* and *Who chooses the details?* Wrenched from a religious context, the two paintings of Christ are aestheticized by the museum. At the same time, the delicacy of

Lawler's photographs matches the paintings and their settings, collapsing all into a seamless elegance.

Photography is doubly appealing to the feminist position, as a "challenge to traditional definitions of fine art—especially to the primacy of painting" from which women are historically excluded.[37] Photographic appropriation, using the camera to copy preexisting images, also reconfigures the concept of the unique and original *master*piece. Charlesworth cuts pictures from newspapers, books and magazines and has them photographed, acknowledging photography as fiction. In her recent work, she explores representations of nature and the body by scavenging the history of art, superimposing, for example, a Leonardo study of female anatomy on a sketch of a tree by Bosch in *Nature Study*, 1991. In her *Objects of Desire Series*, seductively potent images are isolated on a richly hued field to suggest resonant new realities.

Appropriation, as it was developed in the late seventies, was a specifically critical technique. As a deconstructive method, it draws our attention to the manipulative potential of the media. With a less political agenda, Conceptualists in the sixties also appropriated texts and images. Kosuth's dictionary definitions and Baldessari's work in particular serve as models.

Baldessari's *Police Drawing*, 1971, was the result of the artist wandering around, unannounced, in a friend's drawing class. A police artist was sent into the classroom to make a drawing based on the students' description of the visitor. Since he handed over his brush to a hired sign painter in 1966, for works such as *Everything Is Purged From This Painting...*, 1967–1968, Baldessari has culled words and images from the popular media, such as art magazines, textbooks and television. Many of the photographs which make up the *Blasted Allegories* are of Baldessari's TV screen, and *Worried Appeal Cycle,* 1978, from that series includes snapshots from a corner in Westwood Village in Los Angeles. Individual words were assigned to the photographs, which were filed to make an "image dictionary," and subsequently arranged according to a specific system. Since 1976, Baldessari has been selecting, editing and rephotographing film stills. *Helicopter (Blue Sky and Cloud)/ Covered Wagon (in Flames)*, 1991, relies on our familiarity with such generic images. It makes a formal connection between the spokes of the wagon wheel and the propeller of the helicopter, speaks to the issues of assault and rescue, and juxtaposes past and present modes of transportation.

Richard Prince made his first pictures of pictures in 1977, photographs of living rooms in the

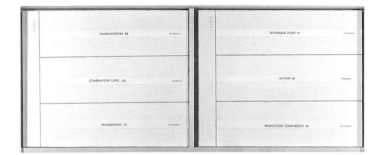

Antonella Piemontese
*Quadrants for the
Chapters Toward
Knowledge* 1991
(detail)

New York Times, and is responsible for the currency of rephotography. Working for *Time-Life,* he was familiar with advertising techniques, which are made transparent in his early work. *Untitled (jewelry against nature),* 1978-1979, is a photograph of a Tiffany advertisement for gold acorn earrings suspended from leafy branches. Doubling and highlighting the seductive nature of photography, Prince makes his photographs as attractive to us as the earrings are to the targeted consumer. Although artists such as Sherrie Levine and Barbara Kruger practice a comparable technique, Prince selects potent images, such as the war pictures, that operate on levels other than the didactic.

According to Michael Clegg and Martin Guttmann, it was in the mid-seventies "that the specifically political content of conceptual art was understood." From an awareness of the gallery space as architecture to be claimed, awareness shifted "to more realistic notions, ones which directly involved the social fabric in which art was made." While this approach still characterizes Clegg & Guttmann's authoritarian portraits of business men and art collectors in the 1980s, recently they have felt "a necessity to shift from a preoccupation with

content—Art as Critique—to experimentation with new modes of communication."[39] The book as container of knowledge, housed and structured by the library, has been the focus of Clegg & Guttmann's work since 1990. For *The Free Public Library,* 1990, the collection of a small library in New Jersey was photographed, bookcase by bookcase, life-size. Accompanying the photographs was a card catalogue, made up from the information visible on the spines of the books in the photographs. *The Open Library,* 1991, a three-month installation of an outdoor library in Graz, Austria, actually made books available to readers/viewers, who took books from a bookcase, or brought their own books to fill it. In the present exhibition, documentation of the project by three sociology students appears in notebooks on a library table beneath a photograph of the bookcase.

Buzz Spector has spent most of his life working with books, as an editor, publisher, critic and artist. In 1987, he exhibited his personal library in bookcases made impenetrable by clear Plexiglas fronts. While Clegg & Guttmann's photographs of bookcases provide a depersonalized analysis of systems of classification, Spector here revealed the source of the thoughts which construct the

self of the artist. *Malevich: Eight Red Rectangles,* 1991, also has autobiographical references, as it pays homage to Kasimir Malevich, a countryman of Spector's father, who emigrated to the United States from Russia in 1923. Malevich's Suprematist painting provides the structure for positioning the apertures in the wall equal in size and placement to the red books on the floor. The pages of the books are blank, in homage to Malevich's desire for the liberating void beyond perceivable reality.

Antonella Piemontese also uses books for her elaborate collages. *Quadrants for the Chapters of Knowledge,* 1991, is made up of fragments of chapter headings from a typing textbook. Each heading, and the time it takes to complete the lesson, are pasted to a page from a notepad and all are housed in framed boxes. Knowledge is accumulated as the perceiver reads the work, and, as Piemontese points out, "An action and/or operation may repeat itself but will be different due to the constant amount of knowledge received through the experience of that action/operation in earlier time frames."[40] Paradoxically, upon completion of the project, the perceiver has not learned how to type.

Not surprisingly, the dictionary, as a compendium of

knowledge presented as fact, is a fertile field for Conceptualists. Duchamp used it as early as 1913, for his *Erratum Musical*; and his *Green Box* of 1934 contains the following note: "Take a Larousse dictionary and copy all the so-called abstract words, i.e., those that have no concrete reference; substitute for them schematic signs to form the basis of a new alphabet." Art & Language's *The Black Book*, 1967, is composed of alphabetized clippings of dictionary definitions of art terms—e.g., Aesthetic Moment, The; Amusement Art; Analytical Cubism—which absurdly reduce the visual to the verbal. Kosuth's *Proto-Investigations* and *First Investigations* also derive directly from the dictionary, and may be exhibited with the original entries alongside. No matter what its form, Kosuth's work is rooted in the question of meaning-operations. Going to the dictionary to look up a word is a model of the way we comprehend the world and determine the meaning of events.

"If you don't want to know the definition, don't open the dictionary!" declares Mike Kelley's *Know Nothing...*, 1982-1983. Paired with this inscription is a picture of the cover of the all-too-familiar *Cliff Notes*, used by students to crib for their book

Mike Kelley
Hypnosis Drawings
1985
(detail)

reports. Kelley's work explores the bravura and confidence of adolescence. Drawn with an utterly sincere as opposed to appropriative hand, his work speaks of the genuineness of the human spirit, unspoilt by the manipulation of the media or academic theory. Kelley's style, and much of the content of his work, is indebted to the comics—not to the crisp and wholesome sort used by Warhol or Lichtenstein, but to those with a ragged and perverse edge—which entice teenage boys. While Richard Prince's appropriated humor is adult, like Kelley's it is both amusing and terrifying in what it reveals. Many of the jokes in Prince's paintings and drawings spoof psychoanalysis, a decidedly urbane obsession. He also recasts old stand-up routines about alcoholics and marriage, *New Yorker* cartoons and *The Far Side* comics.

In 1984, Huebler drew his own comic strip, "Crocodile Tears," which ran in the *L.A. Weekly*. One of the most potent strips appears again in the left-hand panel of *Crocodile Tears: The Signature Artist (Napoleon)*, 1990. The reference is to a story Huebler read years ago about a nineteenth century portraitist who committed suicide after failing to procure commissions for anything but paintings of Napoleon. Huebler's use of the *L.A. Weekly* newspaper as a medium for the distribution of art is in keeping with the early Conceptualists'

disdain for the precious object. While the recent *Signature Artist (Napoleon)* is indeed a handsome object, it speaks nevertheless of the melancholic homelessness of painting and the utter futility of the object demanded from an artist by the patron or collector.

Kelley's comic *Hypnosis Drawings*, 1985, were made by people under hypnosis who were asked to respond to questions about a diagram by Kelley. The diagram is a figure, an insect, an hourglass, a floorplan and a map, on which Kelley's imaginary Monkey Islands can be found. Although Kelley's is a map of the mind, it recalls Huebler's *Site Sculpture Projects*, based on actual maps, yet imagined rather than perceived. Art & Language's *Map to not Indicate...*, 1967, is part of a comparable project, and uses language to specify what is left out while still describing a geographic place readily identified and known by the perceiver.

David Bunn highlights the conventional as opposed to natural aspect of the maps which divide the countries of the world. His 1989 installation, *Curvature (Some Projections)*, recreated Frederick Kiesler's 1940s design of Peggy Guggenheim's Art of This Century Gallery in New York. Projecting from the curved walls of Bunn's gallery at the Los Angeles County Museum of Art were resin-coated Polaroids of out-of-focus details of maps between

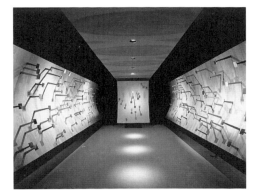

Fig. 1
David Bunn
*Curvature
(Some Projections)*
1989

the Tropics of Capricorn and Cancer. Quotes from Henry Miller, André Breton and others were inscribed on the rods supporting the photographs. A key to Bunn's complex puzzle was provided by schematic diagrams which identified the sources of the quotes and photographs. Bunn continues to emphasize blurred boundaries of time and place in his *Projections No. 1,* 1990, larger versions of the map photographs located strategically on the wall. By making impenetrable, brightly colored and apparently abstract pictures out of political situations, he draws our attention to the artifice and artificiality of maps.

Christopher Williams also deals with the space of the world through the project of geography. *Angola to Vietnam* *, 1989, consists of photographs of glass models of plants from twenty-seven countries where terrorist kidnappings have occurred. In book form, this work concludes with a photograph of the cover of an *Elle* magazine which pictures young models wearing sailor hats inscribed with the names of countries. Williams's *Bouquet, for Bas Jan Ader and Christopher D'Arcangelo,* 1991, evolves from the same magazine cover. A photograph of a bouquet of flowers native to each country on the models' hats is mounted on a wall. The dimensions of this wall commemorate those of a wall built by the late D'Arcangelo and others as a Conceptual performance in

1978. Memorialized, too, is Ader, a Conceptual artist who was lost at sea in 1975.

Conceptualists often open out their ideas to include or embrace those of other artists. The focus on shared cultural ideas at the expense of self-expression provides an ideal arena for production by groups such as Art & Language and Clegg & Guttmann. Collaborative efforts also defy the myth, intact since the Renaissance and central to modernists such as Jackson Pollock, of the artist as lone, creative genius. In 1987, Williams and Stephen Prina acted as collaborators and curators by selecting a picture by *Los Angeles Times* photography contest winner John L. Grahm for exhibition with their *Construction and Maintenance of Our Enemies.* Grahm's color photograph of the Huntington Botanical Gardens in San Marino, California, was a foil for their own black and white photographs of the same gardens, which were accompanied by plaques identifying the plants in the pictures. Williams' investigation of botanical symbolism neatly complements Prina's concern for the implications of arrangement, here expressed by the pseudo-naturalism of the gardens.

Collapsing the Surrealists' collaborative drawing game, known as the Exquisite Corpse, into the nineteenth century Realist paintings of Edouard Manet, Prina's *Exquisite Corpse: The*

Complete Paintings of Manet, 1991, includes a chart or index listing all of Manet's paintings. Based on a widely distributed paperback book on Manet, discredited by most scholars, Prina's on-going project examines the systematizing of an artist's oeuvre. Ghostly ink washes by Prina replicate the scale of each of Manet's paintings, and are identified by title, date and location of the original painting.

Thomas Locher has used numbers and words to convey and confound thought since he began exhibiting in Germany in the mid-eighties. He is clearly indebted to earlier American and French Conceptualism, such as Bernar Venet's reproduction of complex and impenetrable mathematical formulae. In Locher's work, however, numbering systems are arbitrary. Each piece of hardware in his *Door* photographs is dutifully numbered, parodying systems of knowledge which divide, name and label, so that a progression appears to be established, yet no equation is forthcoming. The impenetrability of the numerical system and of the locked doors themselves is reinforced by the glassy surface of the photographs. Although Locher actually built the doors, they exist for the perceiver in the realm of ideas.

Glenn Ligon also uses doors as supports for his thoughts, or more precisely, the

thoughts of others. Phrases identified with black culture, such as *I Do Not Feel Tragically Colored...*, 1990, and *I Feel Most Colored When...*, 1990, (from a 1928 essay by Zora Neale Hurston, "How It Feels to Be Colored Me"), are stenciled repeatedly on his paintings. Clean and legible at the top of the panel, the phrase be-comes gradually dense and smeared, until it is virtually obliterated at the bottom, evoking Warhol's repetition of the face of Marilyn Monroe, whose image and persona are progressively obscured by ink. The most painterly work in the exhibition, Ligon's pieces address social issues as they are articulated and represented by language.

Ligon exemplifies the restructuring of knowledge that has occurred during the last quarter century. In 1966, On Kawara began his *Date Paintings*, each inscribed with only the date on which it was painted. Two years later, he sent his "I got up..." postcards, with the precise time (e.g., 8:09 A.M.) he awoke each day, as "a kind of self-reassurance that the artist does, in fact, exist."[41] Where Kawara's works depend on a Cartesian perspective on the function of self-expression in art, Ligon's use of the first person emphasizes the contemporary concern with the cultural construction of identity.

Fig. 2
Christopher Williams
Vietnam
1989

Recent Conceptual Art often takes the form of projects rather than documents. Rooted in the kinds of systems used first by Minimalists Judd and LeWitt, and subsequently by Bochner, Huebler and Art & Language, the new work takes the structures, the codes and the institutions of the world as its subject. Whatever system is at hand to be analyzed, the artist permutes it completely, so that the perceiver is drawn into its orbit, and must work through the system to arrive at the concept. As a result, knowledge becomes synthetic. Kosuth's opinion in 1969 that "Works of art are analytic propositions.... They provide no information whatsoever about any matter of fact,"[42] now looks closer to the formalism it intended to displace. The expanded definition of Conceptual Art is Huebler's:

I am convinced that the most compelling, the most pertinent issue concerning any kind of art practice today is one that began to surface in the late '60s. It is the issue about whether or not "association"—referencing to worldly matters—will be permitted back into art. It will be around that issue that more and more artists will have to take a position.[43]

Implicated, too, is the perceiver, who cannot be content with the passive aesthetic experience, but is called upon to participate actively in the construction and unraveling of knowledge.

NOTES:

1. Arthur Schopenhauer. "The World as Will and Idea," *Philosophies of Art and Beauty*, eds. Albert Hofstadter and Richard Kuhns. Chicago: University of Chicago Press, 1964, 452–4.

2. Quoted in Charles Harrison and Fred Orton, "Introduction: Modernism, Explanation and Knowledge," *Modernism, Criticism, Realism*, eds. Charles Harrison and Fred Orton, New York: Harper & Row: 1984, xi.

3. Calvin Tomkins. *The Bride and the Bachelors*, New York: Penguin Books, 1976, 13. Duchamp's influence on Conceptualism, while notable, is somewhat overrated since his readymade is first and foremost an *object*.

4. Mel Ramsden. "Jeremy Gilbert-Rolfe's As-Silly-As-You-Can-Get 'Brice Marden's Painting,' *Artforum*, October 1974," *The Fox*, 2, 1975, 8.

5. Sol LeWitt. "Paragraphs on Conceptual Art," reprinted in *Sol LeWitt*, ed. Alicia Legg, New York: Museum of Modern Art, 1978, 166.

6. Douglas Crimp's exhibition *Pictures* of 1977 at Artists Space in New York is evidence of the viability of Conceptual concerns during the period. See Crimp's "Pictures," in *Art After Modernism*, ed. Brian Wallis, New York: The New Museum, 1984, 175–87.

7. Terry Smith. "Art and Art and Language," *Artforum*, February 1974, 50.

8. Mel Ramsden, quoted in Charles Harrison, "Art & Language: Some Conditions and Concerns of the First Ten Years," *Art & Language: The Paintings*. Brussels: Société des Expositions du Palais des Beaux-Arts, 1987, 8.

9. Kosuth was appointed as the American editor. Baldwin, Mel Ramsden (who had come on board from his Society for Theoretical Art and Analysis) and Charles Harrison continued to edit the publication from the mid-seventies until its demise in 1985. The Art & Language Foundation also published three issues of *The Fox* in New York in 1975–6. *The Fox's* six editors included Kosuth and Sarah Charlesworth.

10. "The meaning of a word is its use in the language." Ludwig Wittgenstein, *Philosophical Investigations*, trans. G. E. M. Anscombe. New York: Macmillan, 1953, 20.

11. Victor Burgin. "Situational Aesthetics," *Studio International*, October 1969, 19.

12. Mary Anne Staniszewski. "Mel Ramsden Interview," *Flash Art*, November/December 1988, 107.

13. Michael Baldwin, in David Batchelor, "A Conversation in the Studio About Painting," *Art & Language: Hostages XXV–LXXVI*. London: Lisson Gallery, 1991, 18.

14. Following the publication of Kosuth's "Art After Philosophy" in 1969, Dore Ashton complained in a letter to the editor that Kosuth had pilfered his ideas from Bochner. Kosuth replied that Bochner was a good teacher, but not an important contributor to Conceptual Art. Dore Ashton, "Kosuth: The Facts," *Studio International*, February 1970, 44; Joseph Kosuth, "An Answer to Criticisms," *Studio International*, June 1970, 245.

15. Jeanne Siegel. "Joseph Kosuth: Art as Idea as Idea," *Artwords: Discourses on the 60s and 70s*, Ann Arbor: UMI Research Press, 1985, 221.

16. Barbara Rose, ed. *Art as Art: The Selected Writings of Ad Reinhardt*. New York, Viking, 1975, 70.

17. Christian Schlatter. *Art Conceptuel Formes Conceptuelles: Conceptual Art Conceptual Forms*, Paris: Galerie 1900–2000, 1990, 49.

18. Charles Harrison. "A Very Abstract Context," *Studio International*, November 1970, 195.

19. See Benjamin H.D. Buchloh. "From the Aesthetic of Administration to Institutional Critique (Some Aspects of Conceptual Art 1962-69)," *L'Art Conceptuel, Une Perspective*, Paris: Musée d'Art Moderne, 1989, 46, n. 18; and Kosuth's rejoinder, "Joseph Kosuth Responds to Benjamin Buchloh," *L'Art Conceptuel*, p. 54, pasted into the catalogue just before the opening of the exhibition in Paris.

20. "Art After Philosophy" appeared in *Studio International* in October, November and December of 1969. Parts 1 and 2 are reprinted in *Idea Art: A Critical Anthology*, ed. Gregory Battcock, New York: E.P. Dutton, 1973, 70–101. Michel Claura's letter to the editor, disputing, among other things, Kosuth's date of birth "(it is surprising that a conceptual artist should not know when he was conceived)," *Studio International*, January 1970, 5–6, is a prototype for Buchloh's attack on Kosuth's precedence. See note above.

21. See Robert C. Morgan. "The Situation of Conceptual Art: The January Show and After," *Arts Magazine*, February 1989, 42.

22. Jean-Marc Poinsot. "Deni d'Exposition," *Art Conceptuel 1*, Bordeaux: capc Musée d'Art Contemporain, 1988, 15.

23. Seth Siegelaub [and Charles Harrison]. "On Exhibitions and the World at Large: A Conversation with Seth Siegelaub," *Idea Art*, 168–71. Artist Dan Graham's use of the magazine for the dissemination of art ideas in the mid-sixties is an important precedent for primary information.

24. Seth Siegelaub, "Some Remarks on So-Called "Conceptual Art': Extracts from Unpublished Interviews," *L'Art Conceptuel, Une Perspective*, 92. In contrast, Art & Language did not envision Conceptual Art as "some kind of counter-cultural move against capitalism and galleries." Staniszewski, "Mel Ramsden Interview," 107.

25. Jack Burnham, *Great Western Salt Works*. New York: George Braziller, 1974, 48-50.

26. David Bourdon. "The Razed Sites of Carl Andre," *Minimal Art: A Critical Anthology*, ed. Gregory Battcock, New York: E. P. Dutton, 1968, 103. This would account for the sculptures of Rodin and Matisse as form, Picasso's and Tatlin's as structure, and Andre's own plate pieces as place.

27. Robert Barry, in Arthur Rose [a.k.a. Joseph Kosuth], "Four Interviews," *Arts Magazine*, February 1969, 22.

28. Robert Barry and Robert C. Morgan, "Discussion," *Robert Barry*, ed. Erich Franz, Bielefeld: Karl Verlag, 1986, 97, 67.

29. Quoted in H.H. Arnason, *History of Modern Art*, New York: Abrams, 1986, 564.

30. Douglas Huebler in *January 5–31, 1969*, New York: Seth Siegelaub. 1969, n.p.

31. Lucy R. Lippard and John Chandler, "The Dematerialization of Art," *Changing: Essays in Art Criticism* by Lucy R. Lippard. New York: E.P. Dutton, 1971, 255; Gordon Brown, "The Dematerialization of the Object," *Arts Magazine*, September-October 1968, 56; Ursula Meyer, "De-Objectification of the Object," *Arts Magazine*, Summer 1969, 20-22. Yves Klein was the first to use the term, according to Thomas McEvilley, "I Think Therefore I Art," *Artforum*, Summer 1985, 83.

32. Joseph Kosuth. "Art After Philosophy, Part 3," *Studio International*, December 1969, 212.

33. Lucy R. Lippard. *Six Years: The Dematerialization of the Art Object From 1966-1972*, New York: Praeger, 1973, 43.

34. Lizzie Borden. "Three Modes of Conceptual Art," *Artforum*, June 1972, 71. See also James Collins, "Things and Theories," *Artforum*, May 1973, 34.

35. Kristine Stiles. "Performance and Its Objects," *Arts Magazine*, November 1990, 37.

36. Sarah Charlesworth. "A Declaration of Dependence," *The Fox*, 1, 1975, 5.

37. David Clarkson. "Sarah Charlesworth: An Interview," *Parachute*, December 1987, 13.

38. Laura Cottingham, "The Feminine De-Mystique," *Flash Art*, Summer 1989, 92.

39. Clegg & Guttmann, "On Conceptual Art's Tradition," *Flash Art*, November/December 1988, 99, 117.

40. Artist's statement, 21 August 1991.

41. Lippard, *Six Years*, 50.

42. Kosuth, "Art After Philosophy," *Idea Art*, 83.

43. James Hugunin, *Douglas Huebler: The Map and the Territory*, Los Angeles: Los Angeles Center for Photographic Studies, 1984, 3.

Artists

Art & Language

John Baldessari

Robert Barry

David Bunn

Sarah Charlesworth

Clegg & Guttmann

Douglas Huebler

Mike Kelley

Joseph Kosuth

Louise Lawler

Glenn Ligon

Thomas Locher

Antonella Piemontese

Stephen Prina

Richard Prince

Buzz Spector

Lawrence Weiner

Christopher Williams

Art & Language
Study for Hostage XXIX 1989

John Baldessari
Blasted Allegories (Colorful Sentences):
Worried Appeal Cycle ... (Six Sentences
Sharing Circular Green Intersection)
1978

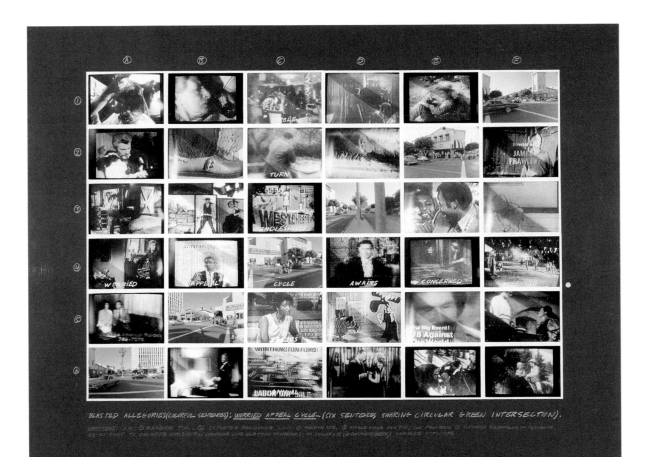

BLASTED ALLEGORIES(COLORFUL SENTENCES): *WORRIED APPEAL CYCLE* (SIX SENTENCES SHARING CIRCULAR GREEN INTERSECTION).

Robert Barry
ALL THE THINGS I KNOW BUT OF
WHICH I AM NOT AT THE MOMENT
THINKING — 1:36 PM; JUNE 15, 1969.
1969

ALL THE THINGS I KNOW BUT OF WHICH I AM NOT
AT THE MOMENT THINKING — 1:36 PM; JUNE 15, 1969.

David Bunn
Projection No. 1 1990

Sarah Charlesworth

Lotus Bowl 1986
Objects of Desire Series

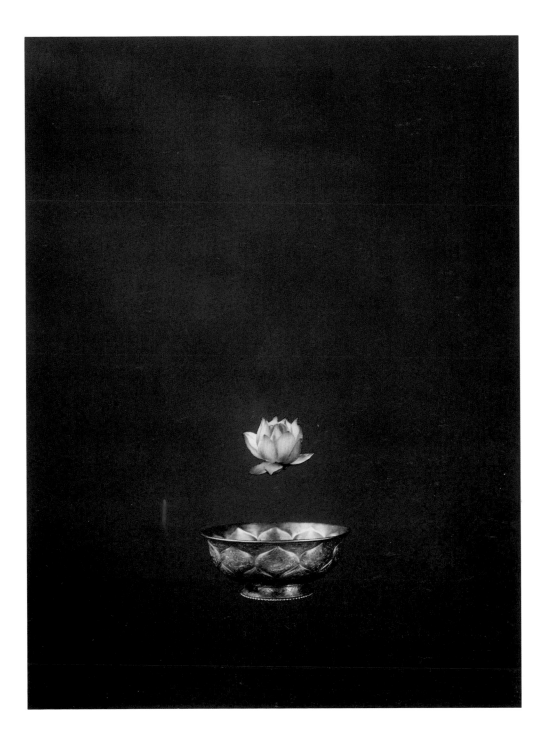

Clegg & Guttmann
The Open Library in Graz, Location I 1991

Douglas Huebler
Crocodile Tears: The Signature Artist (Napoleon)
1990

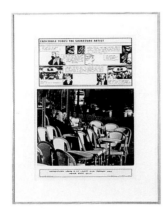

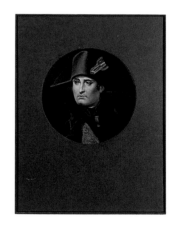

Mike Kelley
*Know Nothing/If You Don't Want
to Know the Definition, Don't Open
the Dictionary* 1982–1983

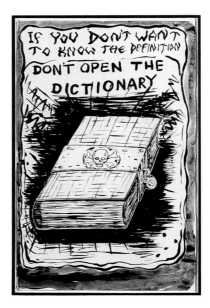

IF YOU DON'T WANT TO KNOW THE DEFINITION DON'T OPEN THE DICTIONARY

Joseph Kosuth

One and Three Hammers
(English Version) 1965
Proto-Investigation Series

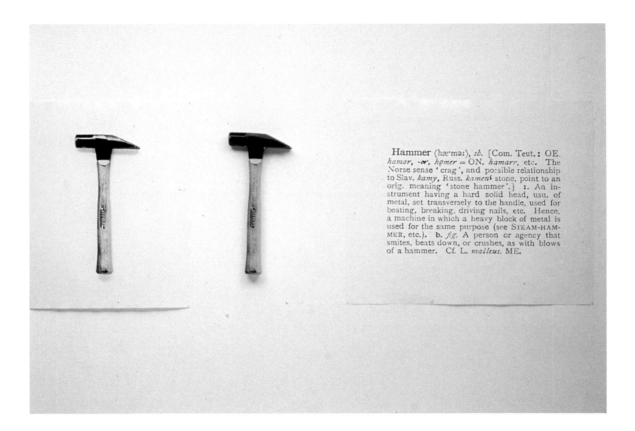

Hammer (hæˈməɹ), sb. [Com. Teut.: OE. hamor, -or, homer = ON. hamarr, etc. The Norse sense 'crag', and possible relationship to Slav. kamy, Russ. kamenĭ stone, point to an orig. meaning 'stone hammer'.] 1. An instrument having a hard solid head, usu. of metal, set transversely to the handle, used for beating, breaking, driving nails, etc. Hence, a machine in which a heavy block of metal is used for the same purpose (see STEAM-HAMMER, etc.). b. fig. A person or agency that smites, beats down, or crushes, as with blows of a hammer. Cf. L. malleus. ME.

Louise Lawler

Who chooses the details? 1990

Glenn Ligon

(Untitled) I Am Not Tragically Colored 1990

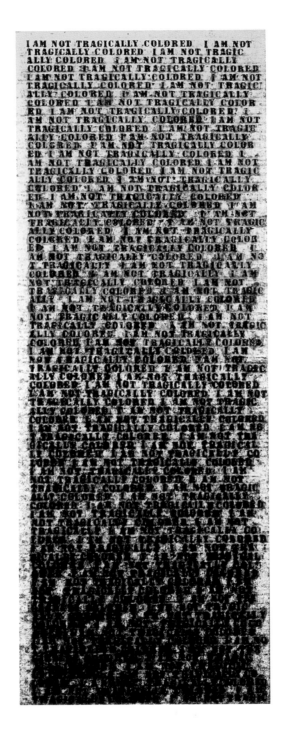

Thomas Locher
1–11 1991

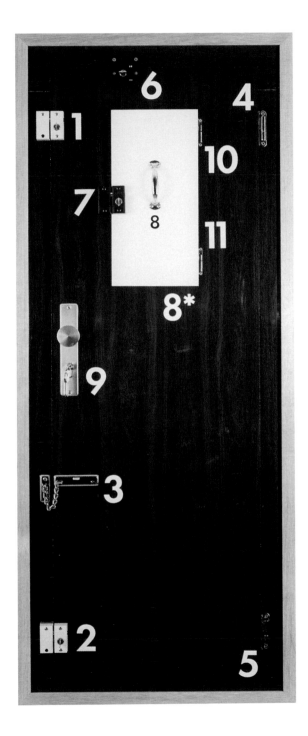

Antonella Piemontese

Weight of Words 1989

Stephen Prina
Exquisite Corpse: The Complete Paintings of Manet
157 of 556
Léçon de Musique (Zacharie Astruc) I
(The Music Lesson)
1870
Private Collection, Boston
December 1, 1991

Richard Prince
Untitled (war) 1986

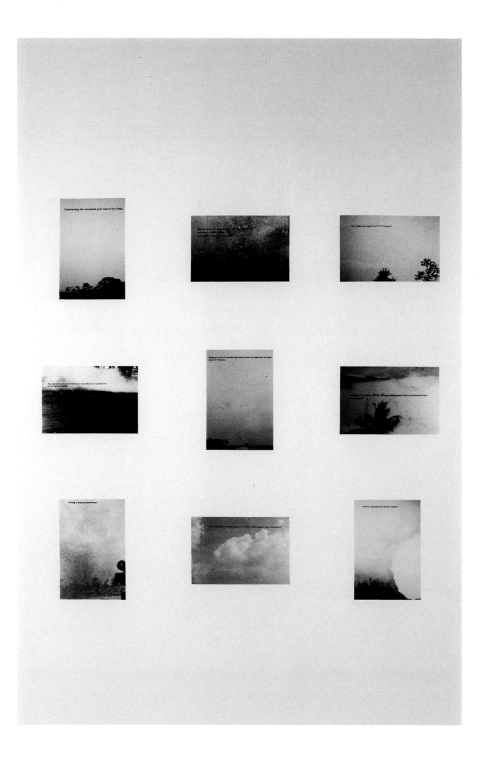

Buzz Spector

Malevich: Eight Red Rectangles 1991

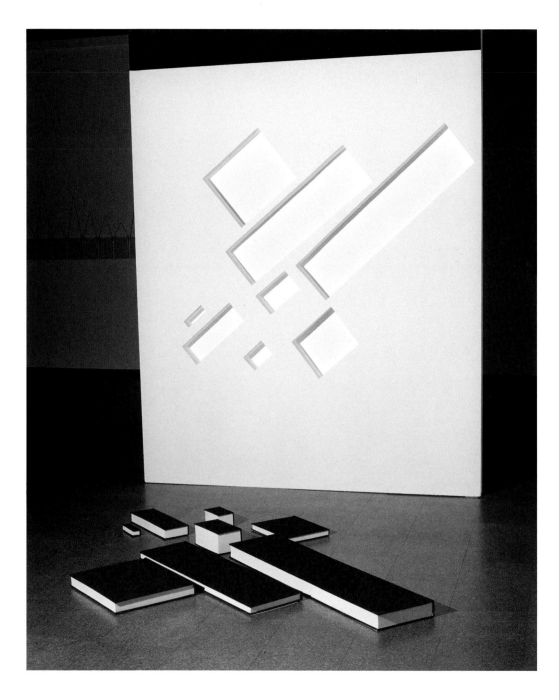

Lawrence Weiner
MANY THINGS PLACED HERE & THERE
TO FORM A PLACE CAPABLE OF SHELTERING
MANY OTHER THINGS PUT HERE & THERE
1980

MANY THINGS PLACED HERE & THERE
TO FORM A PLACE CAPABLE OF SHELTERING
MANY OTHER THINGS PUT HERE & THERE

Christopher Williams

Bouquet, for Bas Jan Ader and
Christopher D'Arcangelo 1991
(detail)

215. But isn't *the same* at least the same?

We seem to have an infallible paradigm of identity in the identity of a thing with itself. I feel like saying: "Here at any rate there can't be a variety of interpretations. If you are seeing a thing you are seeing identity too."

Then are two things the same when they are what *one* thing is? And how am I to apply what the *one* thing shows me to the case of two things?

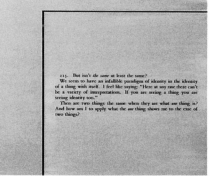

Joseph Kosuth
'215 Twice (+216., After Augustine's Confessions) 1990

Speaking to Contemporary Culture:
Notes and Excavations

Phyllis Plous

In the past twenty-five years, three overlapping generations of Conceptual and post-Conceptual artists have made some of the most eloquent and boldly conceived art of our time. These artists, well-read and street-wise, have combined language- and image-based forms with systems of mapping and diagramming, documentation and archivism, to convey their ideas in works that have infused the modernist—and the postmodernist—enterprise with new critical power.

Situated near the end of a cultural cycle, early Conceptualism was a reaction from within modernism, prompted by the enervated condition of abstract art and the dogmatism of formalist theory. A similar restless spirit was being felt in architecture, literature, music and dance and had become an international phenomenon by the end of the sixties. In attempting to upset late modernism's institutionalized framework, Conceptual Art was not alone. Other movements assumed a comparable attitude: Process Art, with its regard for procedures and material and its anti-form stance; Pop Art, with its high-style, low-brow imagery; and Minimal Art, with its obsessively lean yet dramatic objects. Linked to the counterculture movement, artistic opposition was an aspect of the explosive impulse challenging sanctioned attitudes. Many artists resisted the mystique and

hermeticism pervading the artistic enterprise. They urged alternative modes of representation that could extend art's subject matter and ensure its survival in a society oriented toward commercial goals.

Following World War II, increasing numbers of young artists had enrolled in the recently established art departments of colleges and universities. Although tentatively adhering to a beaux-arts curriculum, some of those students and their artist/professors began to downplay its relevance.[1] Added to studio instruction was the opportunity to read and debate theories of psychoanalysis, social structure, language, phenomenology, ontology and myth as advanced by Freud, Marx and Wittgenstein, Husserl and Heidegger, Sartre, Merleau-Ponty and Lévi-Strauss among others. This was especially notable in America where, before the war, art practice and its criticism had been relatively immune to theoretical developments. It is no wonder that reading, looking and art-making began to be bound into a single synaesthetic activity, or that art practice and theory were becoming interdependent. By the early sixties, many artists were exploring the theoretical implications of art-making and art's role in society. For some, the framework in which art was seen became a subject for interrogation,

whether museum, gallery or private collection. Others, detecting a collusion between art and capital, opted for alternative spaces in which to show their art.

From the start, Conceptualism's rigorous contextual discourse contributed to the disruption of late modernism's traditions and fostered an artistic and intellectual free-for-all. Begun in naiveté, the motivation was clearly political. Conceptual artists rejected modernism's declaration that the object was autonomous and that cultural and social associations should be excluded from consideration. They refused modernism's repressive material practice and quixotic faith in science and technology as chief catalysts for progress. The very act of art-making was questioned: what was art, and who was empowered to decide? To deal with such issues, artists had to explore how concepts were articulated and presented in language. They studied language as an encoding of culture and declared that the dynamics of art lay in mining ideas from the culture. What mattered most was how an idea could be constructed, could be developed in time, and could be investigated through language. Designation and contextualization were Conceptualism's early tools. Its materials were concepts, language and the use of photography for documentation.

Conceptual Art's assault reached full if frustrating effect in the impossible dream of demateri-alization. For Conceptualists, the art work functioned in a public way as a container and bearer of ideas between the self and the world rather than as an aesthetic object for the enjoyment of an elite. In fact, Conceptual artists were responsible for the art world's beginning to refer to their production as *works* rather than as *objects*. The different connota-tions of the two words signal a cultural change in art's vocabulary. As artists shifted their interest from the art *object*, usually associ-ated with a sensuous experience limited to an elite, to the making *of a work*, a term generally associ-ated with the notion of labor or performance, they were hoping to open art to what was at least in theory a broader audience. In another shift in language, even what qualified as an object was changing. Lawrence Weiner has asserted that an "object" did not have to be something "solid," and calling a Conceptual work "ephemeral" did not disqualify it from being considered an object: "If something turns up in 15 or 20 essays or 15 or 20 magazine arti-cles, it is being used as an object. We have to redefine what 'ephemeral' means."[2]

Central to Conceptualism's precepts were a Duchampian insistence on the importance of the ideas behind art, and an emphasis on systems for the pro-duction of cultural rather than per-sonal meanings. The profound and far-reaching implications that emerged from this position led to Conceptualism's collapsing of the boundaries between artistic forms and their aesthetic containers. Despite its link with modernism, Conceptual Art's interest in how art acquires meaning was begin-ning to foreshadow the concerns of postmodernism.

Conceptualism's early adoption of words and subse-quent addition of photography— and other types of mechanical and electronic reproduction—as mate-rial for art, in a class with paint and bronze, opened the way to new territory. In the *Visual/Verbal* exhi-bition at this museum in 1975, Douglas Huebler exposed viewers to a chapter of his ongoing work, initiated in 1971: *Photographing Everyone Alive (166; Variable Piece #70; 1971, Audience Partici-pation Piece)*. The work had ties to performance art in that the artist used viewers as public par-ticipants to assist in his system of documentation. Huebler stated that in adding photographic docu-mentation to descriptive language and the implication of mapping, he considered them as "co-existing material components," which were different but equally power-ful modes of communication. For Huebler, it was the artist's system of documentation, which entered the viewer's mind, and the dura-tion of time involved in the pro-cess that were interesting, not the document itself, which he did not consider "art."[3] In this Huebler differs from traditional photogra-phers, for whom the expressive nature of the medium is paramount. Had Conceptual artists treated the photographic component as a separate item, such an act would have diluted the meaning of their work. This is not to suggest that Conceptual Art eschewed the visual. In the long run, its sensibility, which still regards language as the condition for vision, leaves the choice of medium an open-ended process.

Early Conceptual works were a contradictory mix of sim-plicity and complexity. Language as a cognitive element took prece-dence over perception through the senses as artists questioned not only the limits of our percep-tion but the actual nature of per-ception. Often, as in the case of Robert Barry's word pieces, they created invisible, abstract situa-tions. Conceptual pieces were meant to be more than isolated or insulated objects as exemplified by Barry's evocative *ALL THE THINGS I KNOW BUT OF WHICH I AM NOT AT THE MOMENT THINKING. . .*, 1969.[4] Whether engaged in dematerializing the object, posing contextual ques-tions or uncovering hidden agen-das, artists invested the subject rather than the object with auton-omy. Although they had an acute

EVERYTHING IS PURGED FROM THIS PAINTING
BUT ART, NO IDEAS HAVE ENTERED THIS WORK.

John Baldessari
*Everything Is Purged From
This Painting But Art, No Ideas
Have Entered This Work*
1967-1968

need to uncover the reasons behind events and sometimes to document them, they also had a pragmatic understanding of all types of information. One way or another they concentrated on broadcasting their ideas by means of ". . . alternative forms, alternative models of the ways whereby new meaning might be fabricated."[5] And they wanted to exhibit outside the art system.

The work of the British collaborative group Art & Language frequently appeared in magazines, newspapers, catalogues, books, billboards, and journals as well as in an exhibition format. Given the deliberately abstruse texts that its volatile membership created, and Art & Language's ironic relation to aesthetic production, Humpty Dumpty could well have been the perfect metaphor for the uninitiated reader/viewer. Through their journal *Art-Language* they deconstructed modernism's established views and presented a reconstructed program. Acting at once as artist, critic, curator, publisher and dealer, they offered theoretical essays on art as works of Conceptual Art.

The Conceptual Art of Art & Language was work which was either done with no installation in mind, or which was to be realized in social and discursive life outside the conditions of its installation. It presupposed not a form of responsive emotion but a form of responsive activity. It achieved its intended form of distribution, if it did, not through being upheld or otherwise institutionalized, but through being criticized, elaborated, extended or otherwise worked on.[6]

Form wasn't absent from Conceptualism—it had to have a form to exist—but was replenished by meaning and attitude. For example, letters of the alphabet were symbols for sounds that could be grouped together to form words, which in turn could be abstractions of objects and actions and could serve as instruments of knowledge. Barry used words in wall works for their linguistic content and formal configuration. Sometimes letters and words recalled sculptural elements or, when combined in a Weiner piece, the words at once became the medium for a representation of something else and proposed an interaction with things in the world. The existence of a receiver for his art was of paramount importance to Weiner, who believes that once a piece has entered the mind of a viewer, the work belongs to that viewer. These artists operated between the tangible and the intangible. Shifting back and forth between them, they empowered thoughtful viewers to participate actively in and ponder their ideas. Fundamental to their focus on subject matter were the artists' critical insights, wit and intuition. Responsive spectators found a resonance in these works, which served to narrow the gap between art and lived experience.

Simultaneously and with a stunning impact in late 1968, on Los Angeles's La Cienega Boulevard, Kosuth at the old 669 Gallery and John Baldessari at the former Molly Barnes Gallery exhibited new works a few doors away from one another. Subverting art world pieties, both artists avoided traditional aestheticizing and commodification. Baldessari showed a group of paintings including *Everything Is Purged From This Painting But Art, No Ideas Have Entered This Work*, 1967–1968. Kosuth presented a series of twelve 4 x 4' panels, black photostats with white lettering consisting of twelve definitions of the word *nothing*, from his series *Art as Idea as Idea*, 1967. The two bodies of work had been fabricated commercially, demonstrating the artists' common wish to shed formalist issues, and revealed a divergence in approach. In one gallery there were the satirical but hard and pure presentations of Kosuth, and in the other Baldessari's complex and sophisticated quest for knowledge accompanied by his cultivation of the absurd. Conceptual Art was provoking and holding an attraction for a large number of viewers, especially Europeans, who were struck by its intellectual animation and larksome sense of adventure.

Conjoined with Conceptualism's poetic stringency was its iconoclasm, which contributed to the spawning of the pluralist seventies. Artists began to move toward a greater expressiveness and an extension of the possibilities

Louise Lawler
Bird Calls
text 1972
audiotape 1983

for art. The rise of performance art in the late sixties, joined by nontraditional uses of film and videotape and earth, body, narrative, installation and book art, as well as the cross-media works that retained the discrete qualities of each medium, permitted a more specific engagement with cultural issues. Pop Art had brought new cultural icons within the field of art-making, and Conceptual and Process Arts' innovations were making especially strong contributions to the repertory. The three movements were crucial for younger artists, providing them with the possibility of excavating additional material and information to create more complex works. Continuing on from the sixties, explorations of various media brought a steadily advancing technological sophistication. In the sixties, Seth Siegelaub and John Wendler had produced the *Xerox Book*. Now audiotapes and videotapes came into use, as seen in the present exhibition in the works of Baldessari, Barry and Louise Lawler. As the seventies moved on, a new generation of artists was continuously revising the rules. Proposing to function as something more than fuel for the market system, yet interested in finding a greater audience for their art in alternative spaces, they broadened the field. Conceptual Art, made up exclusively of concepts, was being displaced by idea-oriented painting and sculpture and post-Conceptual performance, video and installation.

Although overshadowed by the resurgence of painting and suffering a lack of recognition, Conceptual Art never went away. For example, Buzz Spector has long been engaged with Conceptually-based book art, a site where art and language intersect. Incorporating strategies of Conceptualism into the creation of objects, he has brought his personal experience as writer and publisher to this pursuit. *Malevich: Eight Red Rectangles*, 1991, a recent work of this nature, evokes the context of exhibitions and ideas that our culture has inherited from Kasimir Malevich. Spector's small to over-scale red rectangles, fabricated books deployed across the floor, correspond to the placement of the apertures in his adjoining wall. They suggest sculptural artifacts—geometric, heraldic signs that connote an existential, theosophically inspired and topographical system which echoes the abstract forms in Malevich's Suprematist painting. Commenting on another of Spector's book works, Maria Porges stated:

Spector's use of these elements foregrounds the difference between sincere homage and appropriation What Spector's homage demonstrates is that instead of dismantling history . . . the act of quotation/citation can be a kind of metonymic retrieval, bringing a whole body of work into the present through the reiteration of its signature gesture or material.[7]

In the seventies, artists who were integrating the lessons of Conceptualism into their projects were starting to shift from questions about what art is to more psychological and sociological concerns. To the physicality of works such as *Sound Piece*, 1976, Barry introduced a sensory quality. Its associative and ambiguous word usage as well as the hypnotic rhythm of the words and spaces between them were subliminally poetic and even ironic.

Feminism was also provoking fresh challenges. Often it was artists such as Lawler and Sarah Charlesworth, along with Laurie Simmons, Cindy Sherman and Sherrie Levine, who kept the Conceptual discourse alive by addressing issues of art and social politics, originality, identity and gender. Lawler, in particular, raised the question of gender in her early text piece *Patriarchal Role Calls*, 1972, which listed the names of twenty-eight well known artists, all male. Revised and retitled as *Bird Calls* in 1983, an audiotape was added to extend the piece in which the names of the male artists were performed by the artist as hilarious if exoticized bird squawks. It is a work that questions the resonance and power a male name carries in the history of and market for art. Mary Kelly, Barbara Kruger and Jenny Holzer were dealing with moral values in a more didactic fashion. Other women artists—Judy

Chicago, Faith Ringgold and Ana Mendicta — worked in media that have been traditionally associated with craft. With their emphasis on utilitarianism, process and the lifting of imagery from historical sources, these artists created dense layers of signification that transcended the limits of the materials used. Their conflations, however, were frequently regarded as subordinate pastiches in a period still dominated by white male viewers and artists, dealers and collectors, who found such works insufficiently "serious." Recent shifts in attitude, generated by feminism and multiculturalism, are altering that perception. Now these earlier projects can be more readily understood as introducing ideas and cultural referents concerning identity and power that touched on the status of women as an oppressed social group.

The history of artists and art-making since the late seventies reflects the character of a media-literate generation exposed to critical theory. The implications of the intense discussions about Conceptualism, which had occurred in the late sixties and early seventies, were still vital and were fueling theory and criticism. In addition, young artists nourished on computerized information, rock music, mass media imagery, the comic strip and the disposable television experience were maturing in a homogenized consumer society. In many instances the culturally

encoded works of such artists paralleled the developments of critical theory. Their concern for the implication of Jacques Lacan's psychoanalytic theories opened the way to issues of feminism, while their interest in the social structure of meaning encouraged them to consider issues of authorship and power. On various levels, many artists absorbed the cultural examinations of the Frankfurt School and allied critics, which first introduced the issue of reprentation as a critique of its function — Walter Benjamin, Herbert Marcuse and Theodor Adorno — and the semiological investigations of Ferdinand de Saussure and Roland Barthes. Some explored the notions of Michel Foucault, who posited that knowledge and power each beget the other; Jacques Derrida's views on deconstruction; and Jean Baudrillard's theories regarding the power of the sign and art as seduction.

What is generally called postmodernist art developed as a synthesis of late modernism (the return of painting) and the exploratory tendencies of Conceptual and Process Art. An umbrella term to some and an oxymoron to others, postmodernism holds a respect for other cultures rather than a tendency to dismantle them. It is concerned with semantics, convention and historical memory as well as metaphor and symbolism. It marks a change

from the modernist paradigm and challenges its basic assumptions. Jürgen Habermas, in acknowledging the cultural conflict between the new and the old, suggested that postmodernism might best be defined as *exceeding* modernism.[8] A stage of growth, postmodernism is a radical cultural spirit keyed to our contemporary, media-conscious society. The new quotational paintings that had begun to occur at the end of the seventies were no longer paintings that simply considered color, form and surface. Similarly, photography became a dominant medium, but neither in its traditional form nor as the neutral tool used by the early Conceptualists. Artists with an extensive interest in semiotics explored signs and symbols in a new way. They attempted to discover *what* it was that the sign actually represented and *how* representation itself becomes a signifying structure. They dug into Baudrillard's notions regarding the hyperreal. As artists in the eighties began to deal with the flood of representations coming their way via the media, they turned to an art that engaged those issues. They investigated the role of representation vis à vis context, decontextualization and authorship, re-presenting pictures in a trope that subverted modernism's mythic autonomy of form. Anticipated in the 1977 exhibition *Pictures*, this referred to a displacement of the "one by the

During Operation White Wing helicopters move personnel into assault area.

Richard Prince
Untitled (war)
1986
(detail)

many," involving copies of copies and playing the modernist notion of the unique against the infinity of mechanical reproduction.[9]

When re-presentation supplanted first-hand experience, it acted as a mirror of the culture. Responsibility was shared with the viewer who, in order to locate meaning, had to unravel a double-coding and follow the artists in rethinking the connection between artistic representation and our socially embedded notions of cultural stability. Meanwhile, art's vocabulary was undergoing still another change. As Howard Singerman points out, a number of key words began to be prefixed by "re."[10] Conceptually-based artists were collapsing distinctions between reality and fantasy, appropriating preexisting imagery from the media, subsuming its style and substance, and altering or combining it with visual sources borrowed from history. Moreover, by probing their own terrain, they were negotiating the space between the role of artist as original genius and artist as investigator. In opting for the latter, artists were able to link their newly devised imagery with a radical critique of the sociopolitical apparatus, by which pictures are used to reinforce cultural myths of power and control.

A thorough skeptic, Richard Prince was the first to reply to the authoritative double-speak of advertising and the communications environment. His work illuminated both issue and process. Prince not only dispensed with originality as the primary means for evaluating art, but incorporated the semiotics and imagery of advertising in his work while targeting the official myths of society. In decoding and recoding the visual information of a visual culture, he commandeered actual advertisements, reorganized them slightly and rephotographed them. In turn, they became self-reliant images, replying to the society which had formed Prince and his generation. In *Untitled (war)*, 1986, he used captions that don't necessarily explain the grainy pictures they accompany, nor do the photographs themselves behave in ways which would serve the text with any certainty. Exposing the methods of both photography and the media industry, Prince was putting the already reproduced on notice.

The intensity of Charlesworth's photographic investigations became apparent early in her career. She used newspaper formats in *Guerrilla Piece, June 4, 5, 1979*, creating a ten-part piece by photographing a page in each of ten newspapers over a two-day period. Masking out all but one image and the newspaper's identity, in each frame she re-presented the same Associated Press picture of a Nicaraguan rebel. Her trenchant analysis of the means by which the media manufactures the news indicated the weight and varied political interpretations that can be allotted to an incident by means of location, captioning and scale. Since then, Charlesworth's rephotography and quotations of Renaissance drawings and paintings have appeared in works that remain involved with a self-conscious exploration of knowledge. They have, however, become increasingly seductive, psychological and emotional.

Lawler investigates the cultural framework in which art is seen, photographing art objects in private houses and prestigious museums to underscore the authoritarian functions the objects serve when acquired. She also focuses attention on the market system in which artworks are manipulated. In her subversive parodies *Who chooses the details?* and *Does it matter who owns it?*, both 1990, she elicits her content by exploring the marginal contexts that lie outside or "frame" the artwork, commodifying and signifying it. With both a serious intent and tongue-in-cheek élan, she puts the question: what constitutes the primary exhibit, the art or the institution?

More than ever before, these artists and numerous others commented on the processing, dissemination and reproduction of art in society — often effectively, sometimes cynically — describing

"art in the crisis of representation," a subject summed up in *A Forest of Signs* (1989).[11] There is little question that the best of this work seemed like a marriage of art and theory, offering visual pleasure and intellectual challenge. The artists didn't shy away from addressing the concerns of their generation regarding such issues as race, class, the environment, urban decay, sexual practice or gender, and they provided a vivid cultural portrait of those years by excavating the same culture for both source material and targets.

Sarah Charlesworth
*Guerrilla Piece,
June 4, 5, 1979*
1979
(detail)

Despite Conceptualism's initial push to subvert the autonomy of the object, its aggressive intervention had begun to dissipate. In the eighties overlapping generations of artists sometimes produced not just sophisticated ideas but products that incorporated beautiful, evocative imagery and sensuous surfaces. In turn, expedient collectors, curators, dealers and other commercial interests were coopting the movement within an establishment whose flexible boundaries were governed by the all too familiar forces of a booming art market. As these artists began attracting celebrity attention, many viewers questioned whether the artists were exposing the media or exposing themselves through the media. Had their approach reached a dead end?

In fact, the constant pattern of artistic urgency being coopted by *embourgeoisement* was continuing to give rise to other kinds of consciousness, as artists searched for a way to respond to mass culture. In the long run, the value of new work depends in part on tradition and the value of an artist depends, as ever, on the imaginative transformation of a symbolic system.

Mike Kelley's transformations of punk rock and the cartoon have as much to do with his high-powered art as do the traditions of Surrealism and Conceptual Art. Nearly simultaneous with the production of artists such as Charlesworth, Lawler and Prince, Kelley's Conceptually-based work is rooted in very different historical and cultural sources. Because Surrealism, like Conceptualism, attempts to reproduce mental processes, albeit in another way, it has been retrieved in recent years by younger artists with a Conceptual bent. In the late seventies, Kelley, who already had inclinations toward Surrealist practices, started to appropriate the anti-expressive serial format of Conceptualism in his drawings. Using image association, free association and puns, he was also responding to the ideology and imagery of the Los Angeles punk scene and comic strip culture. However, unlike so many of his peers, the process of making involved Kelley's hand. At first

somewhat reductive, he made drawings with text in series to accompany Rabelaisian performance works. Highly energized and ferociously raw and funny, the performances had created a near cult following in contemporary art circles in California by the mid-eighties. Kelley deals with how things are pictured and, through implication, suppressed in society. More recently, he has included installations that feature stuffed toys found in thrift stores. He disperses these soiled and sad, even creepy, objects in evocative groups in museum and gallery spaces. Introducing mass culture (more visceral than the kind produced by Pop artists) into high-art contexts, Kelley unveils society's conventions and moral values and forces society to confront them. Aware of the cultural decay inherited by his generation, he pushes for regeneration.

A few years later than Kelley and in a wholly different vein of post-Conceptualism, Stephen Prina began to retrieve and rework early Conceptual strategies. He combines spare means with an unerring sense of logic to comment on Conceptual production, its systems and its games. An artist with a penchant for a cultural archivism that relies on frames of reference for its representation, Prina deals with investigatory disclosure. "My work is like an affirmation, dependent on auxiliary textualities."[12] With deadpan

Fig. 3
Mike Kelley
*Empathy
Displacement #15*
1990

presentation, the artist develops ordering strategies in which simulation takes precedence over the real thing. Prina revealed a wily and adventurous sense of ideological ploy in 1988 when he embarked on the task of representing the complete works of the nineteenth-century master Edouard Manet. In *Exquisite Corpse: The Complete Paintings of Manet*, 1991, he mapped out an already existing body of work which he continues to allegorize, creating an ongoing analogical body of works by himself that conceptualizes Manet's oeuvre. Resonant with historical consciousness, Prina's project suggests the multiplicity of authorship while its title references Surrealism, indirectly pointing to the artist's reliance on the intuitive as prime catalyst for Conceptually-based creation.

In *Supplement**, 1990, Christopher Williams rearticulates the processes of representation, reproduction and distribution of information, extending the common ground between art and documentation. Here, he quotes a supposedly objective, scientific process by documenting the ornithological form of institutional collecting. Eight birds, housed in the London Zoo, were photographed by a freelance photographer, and the photographs were captioned according to the zoo's own system of labeling. The rich, warm tones of the photographs

evoke the notion of desirable artifacts as well as the photographer's skillful manipulation in the darkroom. Williams explores his subject in more ways than one. First presenting the photographs within the conventions of traditional genre photography, they go on to excavate institutional resources and contextual boundaries. The photographs, the title and the labels, the frame and the institutional wall are incorporated into the meaning and structure of the work. The clues to unraveling the extratextual signification of this work lie in the artist's title and his meticulous, fetishistic labels.

*Supplement** echoes an earlier project, *Angola to Vietnam**, 1989. In that series, Williams arbitrarily classified his choice of subjects based on countries selected from a list of thirty-six cited in a 1986 report to the Independent Commission on Humanitarian Issues, *Disappeared! Techniques of Terror*. Once again borrowing this list for the equally pseudo classification of *Supplement**, the artist suggests rather precise parallels between terrorist strategies and the colonial stance of nineteenth-century museology, which embodied an arrogating view of the third world. Williams' politicizing of his imagery is a measure of his subtle visual activism and interest in concealed power.

The works of the collaborative team Clegg & Guttmann

directly engage the public in an accessible manner. Overall, their production—the earlier portraits of fictional individuals in institutional board rooms and richly appointed private quarters, the landscapes and the new work which has developed out of the landscapes—are akin to performance. Initiated by the two artists rather than commissioned by the city of Graz, Austria, the predecessor for the work in the present exhibition was a publicly-sited outdoor installation that aimed to draw the community of Graz into the work. The artists constructed a glass-enclosed bookshelf and installed it with a small library where citizens might participate by borrowing, returning and even lending material to the piece. Within a specified duration of time, the work itself functioned as a lending library and a portrait of the community, with students gathering and documenting knowledge/data about the community and its reaction to the artist's project. The present museum installation, an autonomous work, The *Open Library in Graz, Location I*, 1991, includes a photograph of the now abandoned structure and documents the activity the first work engendered. Clegg & Guttmann's documentation and production have come full circle, from the early portraits, which investigated the private reception of art to the communal portrait of Graz and its

intervention in the artists' installation.

Using the tactics of Conceptualism and the art world as his arena, David Bunn addresses issues of ethnicity, race and the first world's relations to developing nations. Two fundamental pieces of information provide viewers with a key for experiencing his allegorical work, *Projection No. I*, 1990: the specifications of latitude and longitude, and each country's name and color on the Mercator projection map

as text material on the labels; also the relationship between the photographs placed along the wall. Viewers are invited to examine and ponder Bunn's abstracted mapping system. Comprising photographic details taken from the map with a Polacolor camera, all territorial labels have been "painted out," deliberately leaving only geographical and political borders. The image was made intentionally out-of-focus, leaving only the juxtapositions of color available. This at once exoticizes the work, privileges its aesthetic location and serves as a point of departure for free association in arriving at a more appropriate political assessment.

Collapsing her game plan into an engagement with the ongoing life of knowledge and culture, Antonella Piemontese combines a variety of materials, including found geometric shapes and book pages with such structures as grid, line, mapping and indexing techniques. From them the artist constructs serial projects which acknowledge the influence of early Conceptual pieces by Sol LeWitt. In *Weight of Words,* 1989, Piemontese has stretched string in triangular outlines, varying their lengths according to the number of words on each of the pages found in an Italian instruction book. Deployed along a wall, *Weight of Words* reads as architectural form. By using these reductive strategies of essential form and repetition, Piemontese achieves associative effects, providing a means of embodying knowledge.

Thomas Locher, on the other hand, presents disordered "systems." Straddling the notions of an unfragmentable whole and a world divided into parts, the artist collapses both into one dynamic. Received knowledge, the kind that the human mind yearns for, is stood on its head. Influenced by ontological investigations and the early Conceptualists' demonstrations of the roles of contingency and chance, he reflects on the subject of natural order vis à vis chaos. At the same time he comments on the systematized production of knowledge and the human fear of disorder. At first glance his works read as meticulous, matter-of-fact photographs of doors (which the artist himself built) bearing precision hardware as well as words and numbers that suggest formulae. Locher sets up a tension between what appears to be an obsessive ordering and the viewer's eventual awareness that there is no "fit" among the offered parts that will make a whole.

Glenn Ligon problematizes the matter of race. In *I Do Not Feel Tragically Colored*, 1991, the artist presented a clear image at the top of his text-based door painting and gradually moved on to a blurred treatment below, introducing a temporal quality that draws our attention to the history of racial inequity. Ligon asserts a positive, savvy attitude. In stenciled fields of repetitive phrases, he makes use of found language as physical symbol to deal directly with the context of everyday experience. Because Ligon interrogates critically rather than positing one specific position, his paintings reach an innovative level that transcends art's contemporary predicament of the overuse of appropriations and theoretical formulae.

Ligon shows us the way out of the dilemma of choosing between being politically correct or aesthetically sophisticated. One of the lessons of Conceptualism is that such a dichotomy derives more from the strictures of modernism and formalist dogmas than

from any factors inherent in the art-making process. The opening up of art to context and knowledge, undertaken by Conceptual artists in the sixties, has transformed our notions of what counts as art and as significance. For viewers, too, there is the invitation to enjoy artworks not just for their surface value but to discover the different possible meanings located within the layers of implication that form the works.

Although at first Conceptual Art was primarily about language games and categorization, it went beyond that phase to address and deal with real issues. It has contributed to the postmodernist realization that an understanding of art must include how it functions in different societies and that an ethnocentrism that situates Western culture as the standard for measuring human achievement is insupportable, both morally and intellectually. In its ability to expose and clarify our understanding of the mechanisms by which knowledge is encoded and used, and how these issues are bound up with questions of social empowerment, the continuing vitality and relevance of Conceptualism are assured.

Glenn Ligon
(Untitled) I Feel Most Colored When I Am Thrown Against a Sharp White Background 1990

NOTES:

1. Arthur Danto. "Approaching the End of Art," *The State of the Art*. New York: Prentice Hall, 1987, 216.

2. Phyllis Rosenzweig. "Interview with Lawrence Weiner," *WORKS* series (exhibition brochure). Washington, D.C.: Hirshhorn Museum and Sculpture Garden, 1990.

3. Douglas Huebler. Artist's statement, May 1975.

4. Robert Barry in Arthur Rose [a.k.a. Joseph Kosuth]. "Four Interviews," *Arts Magazine*, February 1969, 22.

5. Douglas Huebler. "Sabotage or Trophy? Advance or Retreat," *Artforum*, May 1982, 73–6.

6. Charles Harrison. *Essays on Art & Language*. Oxford: Basil Blackwell, 1991, 51.

7. Maria Porges. "Talking Pictures," *Buzz Spector, New California Artists Series* (exhibition brochure). Newport Beach, California: Newport Harbor Art Museum, 1990.

8. Jürgen Habermas. "Modernity— An Incomplete Project," *The Anti-Aesthetic: Essays on Postmodern Culture*, ed. Hal Foster. Port Townsend, Washington: Bay Press, 1983, 3–15.

9. Howard Singerman. "In the Text," *A Forest of Signs* (exhibition catalogue). Los Angeles: The Museum of Contemporary Art, and Cambridge, Massachusetts: MIT Press, 1989, 162.

10. Singerman, "In the Text."

11. For a more complete discussion of re-presentation in the eighties, see *A Forest of Signs*.

12. Stephen Prina. Artist's statement, November 1991.

Works in the Exhibition

Unless otherwise indicated, dimensions are in inches; height precedes width precedes depth.

ART & LANGUAGE

1 *Two Black Squares, Paradoxes of the Absolute Zero* 1966
pencil and ink on paper $36^{1/2}$ x 49
Courtesy John Weber Gallery
New York

2 *Map to not indicate . . .* 1967
letterpress print $19^{3/4}$ x $24^{1/2}$
Courtesy Lisson Gallery, London

3 *Study for Hostage XXIX* 1989
acrylic, ink and pencil on paper
$51^{1/3}$ x $35^{1/4}$
Courtesy Marian Goodman Gallery
New York

JOHN BALDESSARI

4 *Everything Is Purged From This Painting But Art, No Ideas Have Entered This Work* 1967–1968
acrylic on canvas 68 x $56^{1/2}$
The Sonnabend Collection

5 *Police Drawing* 1971
conte crayon on paper 34 x 19
two black and white photographs
8 x 10 each
black and white videotape 30 minutes
Collection of the artist

6 *Blasted Allegories (Colorful Sentences): Worried Appeal Cycle . . . (Six Sentences Sharing Circular Green Intersection)* 1978
black and white/green photographs
on board $30^{7/8}$ x 40
Courtesy Sonnabend Gallery
New York

7 *Helicopter (Blue Sky and Cloud)/ Covered Wagon (in Flames)* 1991
color photographs and acrylic
48 x $24^{1/2}$
Courtesy Margo Leavin Gallery
Los Angeles

ROBERT BARRY

8 *ALL THE THINGS I KNOW BUT OF WHICH I AM NOT AT THE MOMENT THINKING — 1:36 PM; JUNE 15, 1969.* 1969
words painted on wall, dimensions
variable
Collection of the artist

9 *Telepathic Piece* 1969
pages from a catalogue 9 x 12
Collection of the artist

10 *Sound Piece* 1976
2 audiotapes
Courtesy Julian Pretto Gallery
New York

11 *Untitled* 1991
acrylic and ink on canvas 42 x 42
Courtesy Thomas Solomon's Garage,
Los Angeles and Holly Solomon Gallery,
New York

DAVID BUNN

12 *Projection No. 1* 1990
Polacolor photograph on masonite
poured in plastic resin 20 x 24 each

 1 *Brown Western Sahara,*
 18° x 27°N, 6° x 14°W
 2 *Red Mauritania, 13° x 23°N, 6° x 14°W*
 3 *Yellow Mali, 19° x 29°N, 2° x 11°W*
 4 *Purple Libya, 23° x 31°N, 8° x 16°E*
 5 *Brown Libya, 22° x 30°N, 9° x 17°E*
 6 *Red Djibouti, 0° x 13°N, 40° x 50°E*

Lent by Nancy and Ray Fisher

SARAH CHARLESWORTH

13 *Guerrilla Piece, June 4, 5, 1979* 1979
ten black and white photographs,
dimensions variable
Collection Rena G. Bransten

14 *Lotus Bowl* 1986
Objects of Desire Series
laminated cibachrome print with
lacquered frame 40 x 30
Collection Douglas S. Cramer
(Santa Barbara and Santa Monica only)

15 *Bowl and Column (duo)* 1986
cibachrome 41 x 31 each
Collection Chemical Bank, New York
(Raleigh only)

16 *Reverie* 1991
silver print ed. 1/10 $33^{1/4}$ x $25^{1/2}$
Courtesy Jay Gorney Modern Art
New York

17 *Nature Study* 1991
silver print ed. 1/10 $33^{1/4}$ x $25^{1/2}$
Courtesy Jay Gorney Modern Art
New York

CLEGG & GUTTMANN

18 *The Open Library in Graz, Location I* 1991
cibachrome photograph 50 x 70
wooden library table, two chairs and
notebooks
dimensions variable
Courtesy Jay Gorney Modern Art
New York

DOUGLAS HUEBLER

19 *Duration Piece No. 15* 1969
poster and text 26 x $35^{1/2}$ overall
Lent by the artist
Courtesy Richard Kuhlenschmidt
Gallery, Santa Monica

20 *Variable Piece No. 116* 1973
twenty-five photographs
$40^{1/4}$ x $55^{1/4}$
text 8 x 10
Lent by the artist
Courtesy Leo Castelli Gallery
New York

21 *Crocodile Tears: The Signature Artist (Napoleon)* 1990
text $39^{3/4}$ x $30^{3/4}$
gelatin silver print $40^{3/4}$ x $30^{3/4}$
oil on canvas $41^{1/4}$ x 31
Lent by the artist
Courtesy Richard Kuhlenschmidt
Gallery, Santa Monica

MIKE KELLEY

22 *Know Nothing/ If You Don't Want to Know the Definition, Don't Open the Dictionary* 1982–1983
Sublime Series
acrylic on paper 69 x 48 and 42 x 28
The Praxis Collection
Courtesy Rosamund Felsen Gallery
Los Angeles

23 *Hypnosis Drawings* 1985
eight pencil drawings 33 x 27 each
text and diagram 34 x 22 each
Private Collection
Courtesy Rosamund Felsen Gallery
Los Angeles

JOSEPH KOSUTH

24 *One and Three Hammers*
(English Version) 1965
Proto-Investigation Series
hammer and two photostats
20 x 53³⁄₈ overall
Lent by Milwaukee Art Museum
Gift of Friends of Art

25 *Art as Idea as Idea: Nothing* 1967
First Investigation Series
photostat and collaged text
Lent by Charles Perliter and
Ellen Grinstein Perliter

26 *'215 Twice (+216., After Augustine's
Confessions)* 1990
etched aluminum 60¹⁄₂ x 60¹⁄₂
Collection Mary and Robert Looker
(Santa Barbara only)

27 *No Title* 1990
photostat: two panels 10 x 20³⁄₄
Courtesy Margo Leavin Gallery
Los Angeles
(Santa Monica and Raleigh only)

LOUISE LAWLER

28 *Bird Calls*
text 1972
audiotape 1983
recorded and mixed by Terry Wilson
Lent by the artist
Courtesy Metro Pictures
New York

29 *Why pictures now?* 1981
black and white photograph 8 x 10
Lent by the artist
Courtesy Metro Pictures
New York

30 *A photograph of a work* 1983
color photograph 7¹⁄₂ x 9
Lent by the artist
Courtesy Metro Pictures
New York

31 *Does it matter who owns it?* 1990
cibachrome print .28 x 32
Lent by the artist
Courtesy Metro Pictures
New York

32 *Who chooses the details?* 1990
cibachrome print 28 x 32
Lent by the artist
Courtesy Metro Pictures
New York

GLENN LIGON

33 *(Untitled) I Am Not Tragically
Colored* 1990
oil stick and gesso on wood 80 x 30
Lent by Whitney Museum of American
Art, New York
Promised gift of the Bohen Foundation
in honor of Thomas N. Armstrong, III

34 *(Untitled) I Feel Most Colored When I
Am Thrown Against a Sharp White
Background* 1990
oil stick and gesso on wood 80 x 30
Collection Max Protetch

THOMAS LOCHER

35 *1.1*– 5.** 1991
cibachrome photograph, framed
80³⁄₄ x 41¹⁄₄
Courtesy Jay Gorney Modern Art
New York

36 *1–11* 1991
cibachrome photograph, framed
80³⁄₄ x 33¹⁄₂
Courtesy Jay Gorney Modern Art
New York

ANTONELLA PIEMONTESE

37 *Weight of Words* 1989
book pages on panels with string
twelve sections 34 x 15 each
Courtesy Julian Pretto Gallery
New York

38 *Quadrants for the Chapters Toward
Knowledge* 1991
book pages on wood panels in eight
framed boxes 15 x 18 each
Courtesy Julian Pretto Gallery
New York

STEPHEN PRINA

39 *Exquisite Corpse: The Complete
Paintings of Manet*
157 of 556
*Léçon de Musique (Zacharie Astruc) I
(The Music Lesson)*
1870
Private Collection, Boston
December 1, 1991

two panels:
1- ink wash on rag barrier paper
55 x 67³⁄₄
2- offset lithography on paper
22 x 32¹⁄₄

Courtesy Luhring Augustine, New York

RICHARD PRINCE

40 *Untitled (jewelry against nature)*
1978–1979
Ektacolor photograph, ed. 10 20 x 24
Collection of The Chase Manhattan
Bank, N.A.

41 *Untitled (war)* 1986
Ektacolor photograph, A/P 74 x 47
Private Collection
Courtesy Thea Westreich
New York

42 *Untitled* 1990
pencil, ink, and spray paint on paper
Collection Councilman Joel Wachs
Los Angeles

BUZZ SPECTOR

43 *Malevich: Eight Red Rectangles* 1991
free standing wall with eight apertures
and books 96 x 80

books:
a. *Kasimir Malevich* 16⁷⁄₈ x 4³⁄₈ x 2
b. *Suprematism* 36 x 10¹⁄₄ x 1¹⁄₄
c. *with eight red rectangles*
44³⁄₄ x 10¹⁄₄ x 2¹⁄₄
d. *1915* 8³⁄₄ x 5⁵⁄₁₆ x 4
e. *oil on canvas* 5⁵⁄₈ x 1¹¹⁄₁₆ x 1¹⁄₈
f. *57.5 x 48.5* 15³⁄₈ x 5 x 2
g. *Stedelijk Museum, Amsterdam*
5⁵⁄₈ x 3³⁄₄ x 3
h. *Buzz Spector 1991*
12⁷⁄₈ x 10³⁄₁₆ x 1¹⁄₄

dimensions variable
Lent by the artist
Courtesy Roy Boyd Gallery
Santa Monica

LAWRENCE WEINER

44 *ONE KILOGRAM OF LACQUER
POURED UPON A FLOOR* 1969
language + materials referred to
The Panza Collection

45 *MANY THINGS PLACED HERE &
THERE TO FORM A PLACE CAPABLE
OF SHELTERING MANY OTHER
THINGS PUT HERE & THERE* 1980
language + materials referred to
Collection Dorothy and Herbert Vogel

46 *CLEARED COAST* 1991
language + materials referred to
Courtesy Marian Goodman Gallery
New York

CHRISTOPHER WILLIAMS

47 *Bouquet, tor Bas Jan Ader and*
 Christopher D'Arcangelo 1991
 print 16 x 20
 wall 120 x 180 x 4³⁄⁴
 archival corrugated board, archival
 photocorners, compound, 4-ply
 conservamat, 8-ply conservamat, dry
 wall, dye transfer print, glass, lacquer-
 based finish, linen tape, nails, Northern
 maple, plastic set back strips, primer,
 screws, seaming tape, paint and wood
 Courtesy Galerie Max Hetzler
 Cologne
 (Santa Barbara only)

48 *Supplement** 1990
 eight photographs, framed
 32 x 34 each
 Courtesy Galerie Max Hetzler
 Cologne
 (Santa Monica and Raleigh only)

1
Cyprus 1990
1785
8809
Burhinus Oedicnemus
Stone Curlew
Burhinidae
9.11.82
Presented by Philip Wayre,
Norfolk Wildlife Park, Great Britain
Gelatin Silver Print
Edition size: 8 and 5 artist's proofs

2
Guinea 1990
1358
14069
Otus Leucotis
White-Faced Scops Owl
Strigidae
14.7.88
Hatched in the London Zoo
Regent's Park, London, Great Britain
Gelatin Silver Print
Edition size: 8 and 5 artist's proofs

3
Iran 1990
2180
763
Francolinus Pondicerianus
Indian Francolin
Phasianidae
23.7.85
Presented by Mr. R. Ahmed
Gelatin Silver Print
Edition size: 8 and 5 artist's proofs

4
Iraq 1990
2128
15141
Pterocles Alchata
Pintailed Sandgrouse
Pteroclididae
18.11.88
Presented by Cardiff University
Cardiff, Wales
Gelatin Silver Print
Edition size: 8 and 5 artist's proofs

5
Morocco 1990
2128
15141
Pterocles Alchata
Pintailed Sandgrouse
Pteroclididae
18.11.88
Presented by Cardiff University
Cardiff, Wales
Gelatin silver print
Edition size: 8 and 5 artist's proofs

6
Nepal 1990
96
8679
Gracula Religiosa Intermedia
Nepal Hill Myna
Archie
Sturnidae
10.3.878
Presented by Mrs. Lewis
Gelatin silver print
Edition size: 8 and 5 artist's proofs

7
Seychelles 1990
1730
3657
Threskiornis Aethiopica
Sacred Ibis
Threkiornithidae
12.6.79
Hatched in the London Zoo
Regent's Park, London, Great Britain
Gelatin silver print
Edition size: 8 and 5 artist's proofs

8
Zaire 1990
198
4666
Quelea Quelea
Red-Billed Weaver
Ploceidae
15.10.76
Gift to Society from Mr. T.F. Martin
Gelatin silver print
Edition size: 8 and 5 artist's proofs

Christopher Williams
*Supplement**
Cyprus 1990

Selected Chronology: 1964–1992

Group exhibitions list only artists participating in Knowledge: Aspects of Conceptual Art.

1964

EXHIBITIONS

Robert Barry, Westerly Gallery, New York, first exhibition of paintings

Lawrence Weiner, Seth Siegelaub Gallery, New York, first exhibition of paintings

EVENTS

Ian Burn and Mel Ramsden meet in England

1965

WORKS

Joseph Kosuth, *Clear, Square, Glass, Leaning*

1966

WORKS

Art & Language, *Air Show, Air Conditioning Show*

On Kawara begins *Date Paintings*

PUBLICATIONS

Dan Graham, "Homes for America," *Arts Magazine*, December-January 1966–67

EXHIBITIONS

Daniel Buren, Galerie Fournier, Paris, first exhibition of striped paintings

Primary Structures, organized by Kynaston McShine, Jewish Museum, New York (includes Douglas Huebler). Catalogue

Working Drawings and Other Visible Things on Paper Not Necessarily Meant to Be Viewed as Art, organized by Mel Bochner, Visual Arts Gallery, School of Visual Arts, New York

EVENTS

Terry Atkinson and Michael Baldwin meet in Coventry, England

N. E. Thing Co. Ltd. (Ian Baxter) registered in Vancouver, B.C.

1967

PUBLICATIONS

Baldwin, "Remarks on Air-Conditioning," *Arts Magazine*, November

Gordon Brown, "The Dematerialization of the Object," *Arts Magazine*, September–October

Sol LeWitt, "Paragraphs on Conceptual Art," *Artforum*, Summer

Lucy R. Lippard and John Chandler, "The Dematerialization of Art," *Art International*, February

EXHIBITIONS

Art & Language, *Hardware Show*, Architectural Association, London

Language to be Looked at &/or Things to be Read, Dwan Gallery, New York

Nonanthropomorphic Art by Four Young Artists, Lannis Gallery, organized by Kosuth, New York

Opening Exhibition, Museum of Normal Art (formerly Lannis Gallery), New York

Fifteen People Present Their Favorite Book, Museum of Normal Art, New York, Kosuth's first individual exhibition

1968

PUBLICATIONS

Weiner, *Statement*, published by Seth Siegelaub, New York

Carl Andre, Robert Barry, Douglas Huebler, Joseph Kosuth, Sol LeWitt, Robert Morris,

Lawrence Weiner: The Xerox Book, published by Seth Siegelaub and John W. Wendler, New York

EXHIBITIONS

Carl Andre, Robert Barry, Lawrence Weiner, organized by Seth Siegelaub, Bradford Junior College, Bradford, Massachusetts

Carl Andre, Robert Barry, Lawrence Weiner, Windham College, Putney, Vermont

John Baldessari: Pure Beauty, Molly Barnes Gallery, Los Angeles

Douglas Huebler, November 1968, Seth Siegelaub Gallery, New York, first exhibition to exist in catalogue form

Joseph Kosuth: Nothing, 669 Gallery, Los Angeles

Language II, Dwan Gallery, New York (includes Art & Language, Kosuth, Weiner)

EVENTS

Art & Language Press founded to publish *Art-Language: The Journal of Conceptual Art*, edited by Atkinson, David Bainbridge, Baldwin, Harold Hurrell

1969

WORKS

Barry begins *Psychic Series*

PUBLICATIONS

Art-Language: The Journal of Conceptual Art, May

Howard Junker, "Idea as Art," *Newsweek*, 11 August

Kosuth, "Art After Philosophy," *Studio International*, October, November, December

Thomas M. Messer and David L. Shirey, special section on "Impossible Art," *Art in America*, May/June

Ursula Meyer, "The De-Objectification of the Object," *Arts Magazine*, Summer

Arthur Rose, "Four Interviews with Barry, Huebler, Kosuth, Weiner," *Arts Magazine*, February

EXHIBITIONS

Art by Telephone, organized by Jan van der Marck, Museum of Contemporary Art, Chicago (includes Baldessari, Kosuth). Catalogue

Barry, *Closed Gallery*, Art & Project Gallery, Amsterdam

Conception-Perception, Eugenia Butler Gallery, Los Angeles (includes Baldessari, Barry, Huebler, Kosuth, Weiner)

557,087, organized by Lucy R. Lippard, Seattle Art Museum (includes Art & Language, Baldessari, Barry, Huebler, Kosuth, Weiner). Catalogue

Groups, organized by Lucy R. Lippard, Visual Arts Gallery, School of Visual Arts, New York (includes Barry, Huebler, Weiner)

January 5–31, 1969, Seth Siegelaub Gallery, New York (includes Barry, Huebler, Kosuth, Weiner). Catalogue

Konzeption/Conception, Stadtische Museum, Leverkusen (includes Baldessari, Barry, Huebler, Kosuth, Weiner). Catalogue

Language III, Dwan Gallery, New York (includes Art & Language, Baldessari, Huebler, Kosuth, Weiner)

March 1–31, 1969, Seth Siegelaub Gallery, New York (includes Art & Language, Barry, Huebler, Kosuth, Weiner)

Op Losse Schroeven, Stedelijk Museum, Amsterdam (includes Barry, Huebler, Kosuth, Weiner). Catalogue

Prospect '69, Kunsthalle, Düsseldorf, (includes interviews with Barry, Huebler, Kosuth, Weiner). Catalogue

The Simon Fraser Exhibition, organized by Seth Siegelaub, Simon Fraser University Art Gallery, Vancouver, B.C. (includes Art & Language, Barry, Huebler, Kosuth, Weiner)

When Attitudes Become Form, Live in Your Head, organized by Harald Szeeman, Kunsthalle, Bern (includes Barry, Huebler, Kosuth, Weiner). Catalogue

EVENTS

Burn, Ramsden and Roger Cutforth found the Society for Theoretical Art and Analysis, New York

1970

WORKS

Baldessari, *Cremation Piece*, San Diego, California, destruction of all work prior to 1966

PUBLICATIONS

Atkinson, Baldwin, Bainbridge, Hurrell, "Status and Priority," *Studio International*, January.

EXHIBITIONS

Concept Art, Arte Povera, Land Art, organized by Germano Celant, Galeria Civica d'Arte Moderna, Turin (includes Baldessari, Barry, Huebler, Kosuth, Weiner). Catalogue

Conceptual Art and Conceptual Aspects, organized by Donald Karshan, New York Cultural Center in Association with Fairleigh Dickinson University (includes Art & Language, Barry, Huebler, Weiner). Catalogue

18 Paris IV.70, organized by Michel Claura and Seth Siegelaub, 66 Rue Mouffetard, Paris (includes Barry, Huebler, Weiner). Catalogue

Information, organized by Kynaston McShine, The Museum of Modern Art, New York (includes Art & Language, Baldessari, Barry, Huebler, Kosuth, Weiner). Catalogue

July/August Exhibition, published in Studio International in association with Seth Siegelaub (includes Art & Language, Baldessari, Barry, Huebler, Kosuth, Weiner)

Software, organized by Jack Burnham, Jewish Museum, New York (includes Baldessari, Barry, Huebler, Kosuth, Weiner). Catalogue

EVENTS

School of Art founded at California Institute of the Arts, Valencia

1971

WORKS

Huebler begins *Variable Piece #70 (in process) Global*, to "photographically document . . . the existence of everyone alive"

EVENTS

Charles Harrison appointed editor of *Art-Language*

The Society for Theoretical Art and Analysis merges with Art & Language

1972

PUBLICATIONS

Lizzie Borden, "Three Modes of Conceptual Art," *Artforum*, June

Max Kozloff, "The Trouble with Art-As-Idea," *Artforum*, September

Ursula Meyer, *Conceptual Art*, New York

EXHIBITIONS

Documenta 5, Museum Fridericianum, Kassel (includes Art & Language, Baldessari, Barry, Huebler, Kosuth, Weiner). Catalogue

Konzept-Kunst, Kunstmuseum Basel (includes Art & Language, Baldessari, Barry, Huebler, Kosuth, Weiner). Catalogue

1973

PUBLICATIONS

Gregory Battcock, *Idea Art: A Critical Anthology*, New York

James Collins, "Things and Theories," *Artforum*, May

Lucy R. Lippard, *Six Years: The Dematerialization of the Art Object from 1966 to 1972*, New York

EXHIBITIONS

Contemporanea, organized by Incontri Internazionali d'Arte, Parcheggio di Villa Borghese, Rome (includes Art & Language, Baldessari, Barry, Huebler, Weiner). Catalogue

1974

EXHIBITIONS

Idea and Image in Recent Art, organized by Anne Rorimer, Art Institute of Chicago (includes Baldessari, Huebler, Kosuth, Weiner). Catalogue

Michael Asher, Claire Copley Gallery, Los Angeles

1975

PUBLICATIONS

The Fox begins publication, edited by Sarah Charlesworth, Michael Corris, Preston Heller, Kosuth, Andrew Menard, Ramsden, New York

Richard Prince, "Eleven Conversations," *Tracks*, Fall, texts from Elvis Presley bubble gum cards

EXHIBITIONS

Visual/Verbal, organized by Phyllis Plous and Steven Cortright, University Art Gallery, Santa Barbara (includes Baldessari, Huebler)

1977

WORKS

Prince, *Living Rooms*, first pictures of pictures

EXHIBITIONS

American Narrative/Story Art, organized by Paul Schimmel, Contemporary Arts Museum, Houston (includes Baldessari, Huebler). Catalogue

Pictures, organized by Douglas Crimp, Artists Space, New York. Catalogue

Sarah Charlesworth, MTL Gallery, Brussels, first individual exhibition

1978

EXHIBITIONS

Conceptual Art, Julian Pretto Gallery (includes Barry, Huebler, Kosuth, Weiner)

EVENTS

Mike Kelley's first performance, "Poetry in Motion," Los Angeles Contemporary Exhibitions

John Baldessari
Police Drawing
1971

1979

EXHIBITIONS

Buzz Spector, Roy Boyd Gallery, Chicago, first individual exhibition

Concept, Narrative, Document, organized by Judith Tannenbaum, Museum of Contemporary Art, Chicago (includes Baldessari). Catalogue

Louise Lawler, *A Movie Will be Shown Without the Picture,* Aero Theatre, Santa Monica, California

1980

EXHIBITIONS

Opening Exhibition, Metro Pictures, New York (includes Prince)

Richard Prince, Artists Space, New York

Sarah Charlesworth, Tony Shafrazi Gallery, New York

1981

EXHIBITIONS

Clegg & Guttmann, Annina Nosei Gallery, New York, first individual exhibition

Exhibition, organized by Helene Winer, California Institute of the Arts, Valencia, (includes Kelley). Catalogue

Mike Kelley, Riko Mizuno, Los Angeles, first individual exhibiton

EVENTS

Lawler, *Swan Lake,* invitation to attend public performance of the New York City Ballet

1982

PUBLICATIONS

Benjamin H. D. Buchloh, "Allegorical Procedures," *Art in America,* September

Hal Foster, "Subversive Signs," *Art in America,* November

EXHIBITIONS

A Fatal Attraction: Art and the Media, organized by Thomas Lawson, The Renaissance Society, University of Chicago (includes Charlesworth, Prince). Catalogue

Christopher Williams, *Source. The Photographic Archives, John F. Kennedy Library...,* Jancar/Kuhlenschmidt Gallery, Los Angeles

Image Scavengers, organized by Paula Marincola, Institute of Contemporary Art, University of Pennsylvania, Philadelphia (includes Prince). Catalogue

Lawler, *Arrangements of Pictures,* individual exhibition including works by gallery artists and printed matchbooks, Metro Pictures, New York

1983

WORKS

Lawler photographs Weiner's work for *A photograph of a work*

EXHIBITIONS

Artists' Use of Language: In Other Words, organized by Barry, Franklin Furnace, New York (includes Lawler, Weiner)

Master Works of Conceptual Art, Galerie Paul Maenz, Cologne (includes Art & Language, Barry, Huebler, Kosuth, Weiner)

1984

EXHIBITIONS

Content: A Contemporary Focus, organized by Phyllis Rosenzweig, Howard Fox, Miranda McClintock, Hirshhorn Museum and Sculpture Garden, Washington, D.C. (includes Art & Language, Barry, Huebler, Kosuth, Weiner).Catalogue

Difference: On Representation and Sexuality, organized by Kate Linker, The New Museum, New York. Catalogue

Jenny Holzer, Stephen Prina, Mark Stahl, Christopher Williams, organized by Coosje Van Bruggen, De Appel, Amsterdam; Gewad, Ghent. Catalogue

Natural Genre, organized by Tricia Collins and Richard Milazzo, Fine Arts Gallery, Florida State University Tallahassee (includes Charlesworth, Lawler). Catalogue

Pop, Spiritual America Gallery, directed by Prince, New York (includes Charlesworth, Lawler, Prince)

1985

PUBLICATIONS

Thomas McEvilley, "I Think Therefore I Art," *Artforum,* Summer

EXHIBITIONS

The Art of Memory: The Loss of History, organized by William Olander, New Museum of Contemporary Art, New York (includes Charlesworth, Lawler, Prina, Prince, Williams). Catalogue

Infotainment, organized by Peter Nagy, Livet Reichard, New York (includes Charlesworth, Clegg & Guttmann)

EVENTS

Art-Language ceases publication

Prina, *Evening of 19th- and 20th- Century Piano Music,* excerpts from Beethoven's symphonies, Symphony Space, New York

1986

EXHIBITIONS

Clegg & Guttmann and Joseph Kosuth, Jay Gorney Modern Art, New York

Rooted Rhetoric, organized by Gabriele Guerico, Castel dell'Ovo, Naples (includes Clegg & Guttmann, Kosuth, Lawler, Prina, Prince, Williams). Catalogue

1987

EXHIBITIONS

Art and Its Double, organized by Dan Cameron, Fundacio Caixa de Pensions, Madrid (includes Charlesworth). Catalogue

Cal Arts: Skeptical Belief(s), organized by Suzanne Ghez, The Renaissance Society, University of Chicago (includes Kelley, Prina, Williams). Catalogue

Comic Iconoclasm, organized by Sheena Wagstaff, The Institute of Contemporary Arts, London (includes Weiner). Catalogue

LA: Hot and Cool, organized by Dana Friis-Hansen, List Visual Arts Center, M.I.T., Cambridge (includes David Bunn, Kelley, Prina, Williams). Catalogue

The New Who's Who, organized by Marvin Heiferman, Hoffman Borman Gallery, Santa Monica (includes Baldessari, Clegg & Guttmann, Lawler, Prince). Brochure

1987 Biennial Exhibition, organized by Richard Armstrong, Richard Marshall and Lisa Phillips, Whitney Museum of American Art, New York (includes Clegg & Guttmann, Kosuth, Prince). Catalogue

Perverted by Language, Hillwood Art Museum, Long Island University, Brookville, New York (includes Art & Language, Lawler, Weiner)

Thomas Locher, Galerie Tanja Grunert, Cologne

1988

PUBLICATIONS

Robert C. Morgan, "The Situation of Conceptual Art: The 'January Show' and After," and "The Return of Arthur R. Rose," *Arts Magazine*, February

Mary Ann Staniszewski, essays, interviews and statements on Conceptual Art, *Flash Art*, November–December

EXHIBITIONS

Art Conceptuel 1, organized by Jean-Louis Froment, capc Musée d'Art Contemporain, Bordeaux (includes Art & Language, Barry, Kosuth, Weiner). Catalogue

The Binational: American Art of the Late 80's, organized by Trevor Fairbrother, David Joselit and Elisabeth Sussman, Institute of Contemporary Art and Museum of Fine Arts, Boston (includes Kelley, Prina, Prince). Catalogue

Bunn, *Sphere of Influence, Part 1*, Santa Monica Museum of Art, first individual exhibition

Implosion: A Postmodern Perspective, organized by Lars Nittve, Moderna Museet, Stockholm (includes Lawler). Catalogue

Modes of Address: Language in Art Since 1960, organized by Tom Hardy, Amy Heard, Ingrid Periz and Michael Waldron, Whitney Museum of American Art, Downtown at Federal Reserve Plaza, New York (includes Barry, Lawler, Kosuth, Weiner). Catalogue

Sexual Difference: Both Sides of the Camera, organized by Abigail Solomon-Godeau, Miriam and Ira D. Wallach Art Gallery, Columbia University, New York (includes Charlesworth, Lawler, Prince). Catalogue

Stephen Prina, Luhring, Augustine Hodes Gallery, New York

Striking Distance, organized by Ann Goldstein, The Museum of Contemporary Art, Los Angeles (includes Kelley, Prina). Brochure

Utopia Post Utopia: Configurations of Nature and Culture in Recent Sculpture and Photography, organized by Elisabeth Sussman and David Joselit, Institute of Contemporary Art, Boston (includes Prince). Catalogue

EVENTS

Democracy, an ongoing series including a program of four exhibitions, open public "town meetings," lectures, symposium and a publication, *Democracy*, A Project by Group Material, Dia Art Foundation, New York (1987–1991)

1989

EXHIBITIONS

Antonella Piemontese, Julian Pretto Gallery, New York, first individual exhibition

L'Art Conceptuel, Une Perspective, organized by Suzanne Pagé and Claude Gintz, ARC Musée d'Art Moderne de la Ville de Paris (includes Art & Language, Barry, Huebler, Kosuth, Weiner). Catalogue

Camera Culture, organized by Brent Sikkema, Thomas Segal Gallery, Boston (includes Baldessari, Charlesworth)

Deliberate Investigations, organized by Kathleen Gauss and Sheryl Conkelton, Los Angeles County Museum of Art (includes Bunn). Catalogue

Fauxtography, organized by Nora Halpern Brougher, Art Center College of Design, Pasadena, California (includes Bunn, Charlesworth)

A Forest of Signs: Art in the Crisis of Representation, organized by Ann Goldstein and Mary Jane Jacob, Museum of Contemporary Art, Los Angeles (includes Charlesworth, Kelley, Lawler, Prina, Prince, Williams). Catalogue

Image World: Art and Media Culture, organized by Marvin Heiferman and Lisa Phillips, Whitney Museum of American Art, New York (includes Baldessari, Charlesworth, Clegg & Guttmann, Kosuth, Prince). Catalogue

In Other Words, Museum am Ostwall, Dortmund, Germany (includes Lawler, Locher). Catalogue

Ludwig Wittgenstein: The Play of the Unsayable, organized by Kosuth, Vienna Secession, (includes Art & Language, Charlesworth, Clegg & Guttmann, Kosuth, Lawler, Locher, Prince, Williams). Catalogue

Prospect '89, Frankfurter Kunstverein, Frankfurt (includes Barry, Kelley, Locher, Prina, Prince). Catalogue

Words, Tony Shafrazi Gallery, New York (includes Art & Language, Baldessari, Barry, Huebler, Kosuth, Weiner)

1990

EXHIBITIONS

Concept—Decoratif, Anti-Formalist Art of the 70s, organized by Robert C. Morgan, Nahan Contemporary, New York (includes Barry, Huebler, Weiner). Catalogue

The Decade Show, organized by Nilda Peraza, Marcia Tucker and Kinshasha Holman Conwill, The Museum of Contemporary Hispanic Art, The New Museum of Contemporary Art and The Studio Museum in Harlem (includes Lawler, Prince). Catalogue

Focus: Systems, organized by Edward Leffingwell, Municipal Art Gallery, Los Angeles (includes Spector, Williams)

Glenn Ligon: Winter Exhibition Series, P.S. 1 Museum, The Institute of Contemporary Art, Long Island City, first individual exhibition

New Conceptualists, Julian Pretto Gallery, New York (includes Piemontese)

Rhetorical Image, organized by Milena Kalnovsak, The New Museum of Contemporary Art, New York (includes Art & Language, Weiner)

Word As Image: American Art 1960–1990, organized by Russell Bowman and Dean Sobel, Milwaukee Art Museum (includes Baldessari, Barry, Huebler, Kelley, Kosuth, Lawler, Prince). Catalogue

1991

PUBLICATIONS

Robert C. Morgan, "Word, Document, Installation," *Arts Magazine*, May

EXHIBITIONS

Carnegie International 1991, organized by Mark Francis and Lynne Cooke, Carnegie Museum of Art, Pittsburgh (includes Kelley, Lawler, Prina, Williams). Catalogue

Buchstablich, Words and Images in Today's Art, Von Der Heydt Museum, Wuppertal, Germany (includes Barry). Catalogue

Interrogating Identity, organized by Thomas Sokolowski, Kellie Jones, The Grey Art Gallery, New York University (includes Ligon). Catalogue

1991 Biennial Exhibition, organized by Richard Armstrong, Richard Marshall and Lisa Phillips, Whitney Museum of American Art, New York (includes Kelley, Lawler, Ligon). Catalogue

Power: Its Myths and Mores in American Art, 1961–1991, organized by Halliday T. Day, Indianapolis Museum of Art (includes Prince). Catalogue

Third Newport Biennial: Mapping Histories, organized by Anne Ayres and Marilu Knode, Newport Harbor Art Museum, Newport Beach, California (includes Bunn). Catalogue

EVENTS

Parallel History, a series of projects and events including *The Hybrid State* exhibition and catalogue, organized by Papo Colo and Jeanette Ingberman, Exit Art, New York

1992

Photography/Text, Julian Pretto Gallery, New York (includes Baldessari, Barry, Piemontese)

Sarah Charlesworth
Nature Study
1991

Biographies/
Selected Exhibitions/
Bibliographies

Catalogues for individual exhibitions are listed under that column. Catalogues for group exhibitions are listed in the Chronology.

ART & LANGUAGE

Original founders:
Terry Atkinson, Born 1939
Michael Baldwin, Born 1945
David Bainbridge, Born 1941
Harold Hurrell, Born 1940

Current members:
Michael Baldwin, Born 1945, Chipping, Norton, Oxfordshire
Mel Ramsden, Born 1944, Ilkeston, Derbyshire
Both live and work in Middleton, Cheney, Northamptonshire

Selected Individual Exhibitions

1967
Hardware Show, Architectural Association, London

1972
The Air-Conditioning Show (re-constituted 1966 work), Visual Arts Gallery, School of Visual Arts, New York

Documenta Memorandum (Indexing), Galerie Paul Maenz, Cologne

1973
Index III, John Weber Gallery, New York

1975
Art & Language, 1966–1975, Museum of Modern Art, Oxford (catalogue)

1976–1977
Music-Language, Galerie Eric Fabre, Paris; John Weber Gallery, New York; Gallerie Lia Rumma, Rome and Naples

1980
Portraits of V.I. Lenin in the Style of Jackson Pollock, Stedelijk Van Abbemuseum, Eindhoven

1982
Art & Languatge Retrospective, Musée d'Art Moderne, Toulon (catalogue)

1983
Los Angeles Institute of Contemporary Art (catalogue)

1985
Studies for the Studio at 3 Wesley Place, Tate Gallery, London

1987
The Paintings, Palais des Beaux Arts, Brussels (catalogue)

1989
Early Works 1967–1974, Galerie Sylvana Lorenz, Paris

1990
Marian Goodman Gallery, New York

1990–1991
Hostages XXV–LXXVI, Marian Goodman Gallery, New York; *Hostage Paintings: The Dark Series*, Lisson Gallery, London; *Hostages*, Galerie de Paris, Paris (catalogue)

Selected Bibliography

Atkinson, Terry; Michael Baldwin; David Bainbridge; Harold Hurrell. "Status and Priority," *Studio International*, January 1970, 28–31.

Baldwin, Michael. "Conceptual Questionnaire," *Flash Art*, November/December 1988, 105–6.

Cotter, Holland. "Museum Talk: Art & Language," *Art in America*, June 1988, 142–7.

Harrison, Charles. "Conceptual Art: Myths and Scandals," *Artscribe*, March/April 1990, 15–16.

_____. *Essays on Art & Language*. Oxford, England and Cambridge, Massachusetts: Basil Blackwood, 1991.

Harrison, Charles and Fred Orton, eds. *Modernism, Criticism, Realism*. New York: Harper & Row, 1984.

_____. *A Provisional History of Art & Language*. Paris: Edition Eric Fabre, 1982.

Kuspit, Donald. "Of Art & Language," *Artforum*, May 1986, 127–8.

Smith, Terry. "Art and Art and Language," *Artforum*, February 1974, 49–52.

Staniszewski, Mary Anne. "Mel Ramsden Interview," *Flash Art*, November/December 1988, 106–7.

JOHN BALDESSARI

Born 1931, National City, California
Lives and works in Los Angeles

Selected Individual Exhibitions

1968
Pure Beauty, Molly Barnes Gallery, Los Angeles

1971
Ingres and Other Parables, Konrad Fischer, Düsseldorf

1972
Sonnabend Gallery, New York; Galerie Sonnabend, Paris

1975
Recent Work, Stedelijk Museum, Amsterdam (book: *Four Events and Reactions*)

1976
New American Film Makers Series: Baldessari/Wegman, Whitney Museum of American Art, New York

1977
John Baldessari/ Matrix 32, Wadsworth Atheneum, Hartford, Connecticut (brochure)

1981–1982
Work 1966–1980, The New Museum of Contemporary Art, New York (catalogue). Toured to Contemporary Art Center, Cinninnati; Contemporary Arts Museum, Houston

1981
Werken 1966–1981, Municipal Van Abbemuseum, Eindhoven. Toured to Museum Folkwang, Essen

1983
Vanitas Series: Balanced Bowling Ball,Cockroach/Cool(Short Depth of Field)Bubbles/Dandelion, Cockroach, Wire,) Close Up), Stampa, Basel

1985
Centre d'Art Contemporain, Le Consortium, Dijon

1989
Ni por esas/ Not Even So, Centro de Arte Reina Sofia, Madrid (catalogue). Toured to capc Musée d'Art Contemporain, Bordeaux; Centre Julio Gonzalez, Valencia

1990–1992
The Museum of Contemporary Art, Los Angeles (catalogue). Toured to San Francisco Museum of Modern Art; Hirshhorn Museum and Sculpture Garden, Washington, D.C.; Walker Art Center, Minneapolis; Whitney Museum of American Art, New York; Musée d'Art Contemporain de Montreal

Selected Bibliography

Bruggen, Coosje van. *John Baldessari* (exhibition catalogue). Los Angeles: Museum of Contemporary Art and New York: Rizzoli, 1990.

Collins, James. "Pointing, Hybrids, and Romanticism: John Baldessari," *Artforum*, October 1973, 53–8.

Douglas Huebler
Duration Piece No. 15
1969
(detail)

Colpitt, Frances. "John Baldessari," *LA Pop in the Sixties* (exhibition catalogue). Newport Beach: Newport Harbor Art Museum, 1989.

Drohojowska, Hunter. "No More Boring Art," *ARTnews*, 1986, 62–9.

Foster, Hal. "John Baldessari's 'Blasted Allegories'," *Artforum*, October 1979, 52–5.

Gardner, Colin. "A Systematic Bewildering," *Artforum*, December 1989, 106–12.

Knight, Christopher. "The Resurrection of John Baldessarri," *Los Angeles Times*, 18 March 1990, F5, 89.

Kornblau, Gary. "This Is Not to be Looked At," *Art Issues*, Summer 1990, 15–19.

Pagel, David. "Review, Museum of Modern Art, Los Angeles," *Arts Magazine,* September 1990, 83.

Selwyn, Marc. "John Baldessari," *Flash Art*, Summer 1987, 62–4.

Siegel, Jeanne. "John Baldessari: Recalling Ideas," *Arts Magazine*, April 1988, 86–9.

ROBERT BARRY

Born 1936, New York City
Lives and works in Teaneck, New Jersey

Selected Individual Exhibitions

1969
Seth Siegelaub, Los Angeles
Closed Gallery, Art & Project Gallery, Amsterdam

1971
Leo Castelli Gallery, New York

1974
Kunstmuseum, Luzern (catalogue)

1977-1978
Stedelijk Van Abbemuseum, Eindhoven (catalogue). Toured to Museum Folkwang, Essen

1980
Joslyn Art Museum, Omaha (catalogue)

1984
Wallpieces, Galerie Yvon Lambert, Paris

1985
The Renaissance Society, University of Chicago

1987
Galerie Ghislaine Mollet-Vieville, Paris
Julian Pretto Gallery, New York

1989
Paintings and Other Works on Paper, Thomas Solomon's Garage, Los Angeles

1990
Words, Space, Sound, Time . . ., Haags Gemeentemuseum, The Hague

1991
Holly Solomon Gallery, New York (catalogue)

Selected Bibliography

Cotter, Holland. "Robert Barry," *Arts Magazine,* May 1989, 86.

Morgan, Robert C. "Robert Barry's Return to the Visible," *Arts Magazine*, April 1988, 68–73.

Morgan, Robert C. and Robert Barry. *Robert Barry*, ed. Erich Franz. Bielefeld: Karl Kerber Verlag, 1986.

Renton, Andrew. "Robert Barry: Word Project," *Flash Art*, May/June 1991, 122–5.

Rose, Arthur. "Four Interviews," *Arts Magazine,* February 1969, 22.

Rose, Arthur R. "The Return of Arthur R. Rose," *Arts Magazine*, February 1989, 46–7.

Stimson, Paul. "Between the Signs," *Art in America*, October 1979, 80–1.

White, Robin and Robert Barry. "Interview by Robin White at Crown Point Press," *View*, May 1978.

DAVID BUNN

Born 1950, Greensboro, North Carolina
Lives and works in Los Angeles

Selected Individual Exhibitions

1988
Sphere of Influence, Part I, Art in the Raw Series, Santa Monica Museum of Art

1989
Sphere of Influence, Part II, Art in the Raw Series, Santa Monica Museum of Art

1990
Roy Boyd Gallery, Santa Monica
MARGINS 6: David Bunn, Ruminations on a Stone, University Art Museum, Santa Barbara (brochure)

Selected Bibliography

Colpitt, Frances. "David Bunn at the L.A. County Museum," *Art in America*, January 1990, 169.

Gardner, Colin. "David Bunn," *Artforum*, December 1988, 130–1.
Gerstler, Amy. "David Bunn, Roy Boyd Gallery," *Artforum*, September 1990, 166.

Kandel, Susan. "Deliberate Investigations," *Arts Magazine*, December 1989, 103–04.

Knight, Christopher. "Bunn gives viewers insights into sphere of influence," *Los Angeles Herald Examiner*, August 5, 1988, Arts, 4.

Plous, Phyllis. *MARGINS 6: David Bunn, Ruminations on a Stone* (exhibition brochure). Santa Barbara: University Art Museum, 1991.

Singerman, Howard. "Lessons from David Bunn," *Biennial III: Mapping Histories* (exhibition catalogue). Newport Beach: Newport Harbor Art Museum, 1991.

SARAH CHARLESWORTH

Born 1947, East Orange, New Jersey
Lives and works in New York

Selected Individual Exhibitions

1977
MTL Gallery, Brussels (catalogue)

1978
C Space, New York
Centre d'Art Contemporain, Geneva

1979
New 57 Gallery, Edinburgh, Scotland (catalogue)

1980
Tony Shafrazi Gallery, New York

1982
CEPA Gallery, Buffalo (catalogue)

1984
The Clocktower, New York

1985
California Museum of Photography, Riverside, California

1986
International with Monument, New York

1988
Gallery Hufkens Noirhomme, Brussels

1989
Jay Gorney Modern Art, New York

1990
S.L. Simpson Gallery, Toronto

1991
Jay Gorney Modern Art, New York

Selected Bibliography

Clarkson, David. "Sarah Charlesworth: An Interview," *Parachute*, December 1987, 12–15.

Charlesworth, Sarah. " Declaration of Dependence," *The Fox*, 1, 1975, 1–5.

_____. "On Camera Lucida," *Artforum*, April 1982, 72–3.

Deitcher, David. "Questioning Authority: Sarah Charlesworth's Photographs," *Afterimage*, Summer 1984, 4–17.

Denson, G. Roger. "What's in a Word," *Contemporanea*, October 1990. 70–4.

Glantzman, Judy. "Sarah Charlesworth," *Journal of Contemporary Art*, Spring 1988, 56–66.

Grundberg, Andy. "Two Shows: One Works, One Bogs Down," *New York Times*, 13 August 1989, 33, 40.

Saltz, Jerry. "The Implacable Distance: Sarah Charlesworth's *Unidentified Woman, Hotel Corona, Madrid (1979-80)*," *Arts Magazine*, March 1988, 24–5.

Sussler, Betsy. "Profile: Sarah Charlesworth," *Bomb*, Winter 1989–90, 30–3.

Weiley, Susan, "Sarah Charlesworth's Abracadabra," *ARTnews*, March 1991, 116–21.

CLEGG & GUTTMANN

Michael Clegg, Born 1957
Lives and works in Dublin and New York
Martin Guttmann, Born 1957
Lives and works in New York and Palo Alto

Selected Individual Exhibitions

1981
Annina Nosei Gallery, New York

1983
Galerie Eric Fabre, Paris

1984
Galerie Tanja Grunert, Cologne
Cable Gallery, New York

1985
Galerie Lohrl, Monchengladbach (catalogue)

1987
Israeli Museum, Jerusaleum
Jay Gorney Modern Art, New York

1988
Margo Leavin Gallery, Los Angeles

1989
capc Musée d'Art Contemporain, Bordeaux (catalogue)

1991
The Free Public Library, Location No. 1, Graz, Austria

Selected Bibliography

Cameron, Dan. "Clegg & Guttmann: Official Fictions," *Print Collector's Newsletter*, January/February 1988, 204–6.

Clegg, Michael and Martin Guttmann. "On Conceptual Art's Tradition," *Flash Art*, October/November 1988, 99.

Deitch, Jeffrey and Martin Guttmann. "Art and Corporations,"*Flash Art*, March/April 1988, 77–9.

Jones, Ronald. "Clegg & Guttmann and Kosuth at Jay Gorney," *Artscribe*, January/February 1987, 74–5.

Nesbitt, Lois E. "Clegg & Guttmann, Jay Gorney Modern Art," *Artforum*, July 1990, 164.

Spector, Nancy. "Breaking the Codes," *Contemporanea*, September 1989, 36–41.

Tallman, Susan. "Get the Picture?" *Arts Magazine*, Summer 1990, 15–16.

Welchman, John. "Clegg & Guttmann," *Flash Art*, October/November 1986, 70–1.

DOUGLAS HUEBLER

Born 1924, Ann Arbor, Michigan
Lives and works in Wellington, Florida

Selected Individual Exhibitions

1968
November 1968, Seth Siegelaub Gallery, New York

1970
Konrad Fischer, Düsseldorf
Art & Project Gallery, Amsterdam

1971
Leo Castelli Gallery, New York

1972
Museum of Fine Arts, Boston (catalogue)

1973
Westfälischer Kunstverein, Münster (catalogue)

1979
Stedelijk Van Abbemuseum, Eindhoven (catalogue)
An Installation, Los Angeles County Museum of Art

1984
Douglas Huebler: 1968–1984, L.A. Center for Photographic Studies (catalogue)

1985
Richard Kuhlenschmidt Gallery, Los Angeles

1988
La Jolla Museum of Contemporary Art (catalogue)

1990
Holly Solomon Gallery, New York

Selected Bibliography

Auping, Michael. "Talking with Douglas Huebler," *Journal of the Los Angeles Institute of Contemporary Art*, July/August 1977, 37–44.

Gardner, Colin. "The World According to Douglas Huebler," *Artforum*, November 1988, 100–5.

Hopkins, Budd. "Concept vs. Art Object: A Conversation Between Douglas Huebler and Budd Hopkins," *Arts Magazine*, April 1972, 50–3.

Huebler, Douglas. "Sabotage or Trophy? Advance or Retreat?" *Artforum*, May 1982, 72–6.

Kingsley, April. "Douglas Huebler," *Artforum*, May 1972, 74–8.

Lippard, Lucy. "Douglas Huebler; Everything About Everything," *ARTnews*, December 1972, 29–31.

Miller, John. "Douglas Huebler, Holly Solomon Gallery," *Artforum*, November 1990, 164.

Rose, Arthur. "Four Interviews," *Arts Magazine*, February 1969, 22.

Rose, Arthur R. "The Return of Arthur R. Rose," *Arts Magazine*, February 1989, 47–8.

Stimson, Paul. "Fictive Escapades: Douglas Huebler," *Art in America*, February 1982, 96–9.

MIKE KELLEY

Born 1954, Detroit, Michigan
Lives and works in Los Angeles

Selected Individual Exhibitions

1978
Poetry in Motion, performance, Los Angeles
Contemporary Exhibitions

1979
The Monitor and the Merrimac,
performance, Foundation for Art Resources,
Los Angeles, in conjunction with the
collaborative exhibition with David
Askevold: *The Poltergeist*

1981
Meditation on a Can of Vernors,
performance, Los Angeles Contemporary
Exhibitions
Riko Mizuno Gallery, Los Angeles

1982
Metro Pictures, New York

1983
Rosamund Felsen Gallery, Los Angeles
Monkey Island, performance, Beyond
Baroque Literary Arts Center, Venice,
California

1984
The Sublime, performance, The Museum of
Contemporary Art, Los Angeles

1986
*Plato's Cave, Rothko's Chapel, Lincoln's
Profile*, Artists Space, performance with
Sonic Youth, New York; exhibition Metro
Pictures, New York (book)

The Peristaltic Airwaves, live radio
performance, KPFK, Los Angeles, co-
produced by *High Performance Magazine*
and KPFK

1988
Mike Kelley: Three Projects, The
Renaissance Society, University of Chicago
(catalogue)

1989
Pansy Metal/Clovered Hoof, a dance
presentation of silk scarf series in
collaboration with Anita Pace, sponsored by
Rosamund Felsen Gallery, Los Angeles

1990
Galerie Ghislaine Hussenot, Paris

1991
"Half a Man", Hirshhorn Museum and
Sculpture Garden, Washington, D.C.
(brochure)

Selected Bibliography

Armstrong, Richard. "Michael Kelley's
Performance: A Healthful Activity?"
L.A.I.C.A. Journal, March/April 1979.

Cameron, Dan. "Mike Kelley's Art of
Violation," *Arts Magazine*, June 1986,
14–17.

Cotter, Holland. "Eight Artists Interviewed,"
Art in America, May 1987, 165, 197.

Kelley, Mike. "Foul Perfection: Thoughts on
Caricature," *Artforum*, January 1989, 92–99.

_____. "Monkey Island," *Cave Canem*,
September 1982, 122–46.

Knight, Christopher. " `Half a Man' is Wholly
Compelling," *Los Angeles Herald Examiner*,
13 December 1987, E1, 9.

Lewis, James. "Beyond Redemption,"
Artforum, Summer 1991, 71–5.

Martin, Timothy and Benjamin Weissman.
"Mike Kelley," *The First Newport Biennial:
Los Angeles Today* (exhibition catalogue).
Newport Beach: Newport Harbor Art
Museum, 1984.

Singerman, Howard. "Monkey Island," *The
Fifth Biennale of Sydney, Private Symbol:
Social Metaphor* (exhibition catalogue).
Sydney: The Art Gallery of New South
Wales, 1984.

JOSEPH KOSUTH

Born 1945, Toledo, Ohio
Lives and works in New York

Selected Individual Exhibitions

1967
Fifteen People Present Their Favorite Book,
Museum of Normal Art, New York

1968
Nothing, 669 Gallery, Los Angeles

1969
Art & Project Gallery, Amsterdam
Leo Castelli Gallery, New York

1970
The Pasadena Art Museum
Galerie Daniel Templon, Paris

1971
Centro de Arte y Communicacion, Buenos
Aires (catalogue)
Galerie Bruno Bischofberger, Zurich

1973
Kunstmuseum, Luzern (catalogue)

1974
The Tenth Investigation 1974, Proposition 3,
Carmen Lamanna Gallery, Toronto

1975
Praxis I, Lia Rumma Studio d'Arte, Naples

1978
Tekst/Kontekst, Stedelijk Van
Abbemuseum, Eindhoven

1980
Ten Partial Descriptions, P.S.1, The Institute
for Art and Urban Resources, Inc., Long
Island City

1981
The Making of Meaning, Staatsgalerie,
Stuttgart (catalogue)

1985
Joseph Kosuth: 2 Installations, (Zero & Not),
Musée St., Pierre, Lyon

1988
`Modus Operandi' Cancellato Rovesciato*,
Museo di Capodimonte, Naples (catalogue)

1989
Exchange of Meaning, Museum van
Hedendaagse Kunst, Antwerp (catalogue)

1990
*An Exhibition On, About, or Using Ludwig
Wittgenstein*, Margo Leavin Gallery,
Los Angeles

Selected Bibliography

Avgikos, Jan. "Tell Them it was Wonderful:
Wittgenstein and the Nature of Art,"
Artscribe, March/April 1990, 66–9.

Boice, Bruce. "Joseph Kosuth: 2 Shows,"
Artforum, March 1973, 84–5.

Johnson, Ken. "Forbidden Sights," *Art in
America*, January 1991, 106–9.

Kosuth, Joseph. *Art After Philosophy and
After: Collected Writings, 1966–1990*,
Cambridge, Mass: MIT Press, 1991.

_____. *Interviews*. Stuttgart: Edition
Patricia Schwarz, 1989.

Morgan, Robert C. "The Making of Wit,
Joseph Kosuth and the Freudian
Palimpsest," *Arts Magazine*, January 1988,
48–51.

Princenthal, Nancy. "Kosuth at Ground
Zero," *Art in America*, December 1986,
126–8.

Robbins, David. "Joseph Kosuth: Absolute
Responsibility," *Arts Magazine*, April 1987,
62–3.

Christopher
Williams
*Bouquet, for
Bas Jan Ader and
Christopher
D'Arcangelo*
1991

Rose, Arthur. "Four Interviews," *Arts Magazine*, February 1969, 22–3.

Rose, Arthur R. "The Return of Arthur R. Rose," *Arts Magazine*, February 1989, 48–50.

Taylor, Paul. "Joseph Kosuth," *Flash Art*, April 1986, 37–9.

LOUISE LAWLER

Born 1947, Bronxville, New York
Lives and works in New York

Selected Individual Exhibitions

1979
A Movie Will be Shown Without the Picture, Aero Theatre, Santa Monica

1981
Jancar/Kuhlenschmidt Gallery, Los Angeles

1982
An Arrangement of Pictures, Metro Pictures, New York

1984
Home/Museum—Arranged for Living and Viewing, Matrix 77, Wadsworth Atheneum, Hartford, Connecticut (brochure)

1987
Enough, Project Series, Museum of Modern Art, New York (brochure)

1988
Vous Avez Déja Vu Ça, Galerie Yvon Lambert, Paris

1989
How Many Pictures?, Metro Pictures, New York

1990
The Enlargement of Attention, No One Between the Ages of 21 and 35 is Allowed, Museum of Fine Arts, Boston

Selected Bibliography

Bankowsky, Jack. "Louise Lawler," *Flash Art*, April 1987, 86.

Cameron, Dan. "Four Installations: Francesc Torres, Mierle Ukeles, Louise Lawler/Allan McCollum, and TODT," *Arts Magazine*, December 1984, 66–70.

Decter, Joshua. "Louise Lawler," *Flash Art*, October 1989, 127–8.

Fehlau, Fred. "Louise Lawler Doesn't Take Pictures," *Artscribe*, May 1990, 62–5.

Foster, Hal. "Subversive Signs," *Recodings*, Seattle: Bay Press, 1985, 99–120.

Fraser, Andrea. "In and Out of Place," *Art in America*, June 1985, 122–9.

Linker, Kate. "Eluding Definition," *Artforum*, December 1984, 61–7.

Lichtenstein, Therese. "Louise Lawler," *Arts Magazine*, February 1983, 5.

Tallman, Susan. "Whose Art Is It, Anyway?" *Art in America*, June 1991, 59–63.

GLENN LIGON

Born 1960, Bronx, New York
Lives and works in Brooklyn, New York

Selected Individual Exhibitions

1990
Glenn Ligon: Winter Exhibition Series, P.S.1 Museum, The Institute for Contemporary Art, Long Island City

How It Feels to be Colored Me, BACA Downtown, Brooklyn

1991
White Columns, New York
Project Room, Jack Tilton Gallery, New York

Selected Bibliography

Faust, Gretchen. "New York in Review," *Arts Magazine*, December 1990, 104.

Ligon, Glenn. "Profiles," artist pages for *Third Text*, Summer 1991.

Nesbitt, Lois E. "Interrogating Identity," *Artforum*, Summer 1991, 115.

Smith, Roberta. "'Lack of Location Is My Location'," *New York Times*, 16 June 1991, Section 2, 1.

THOMAS LOCHER

Born 1956, Munderkingen, Germany
Lives and works in Cologne

Selected Individual Exhibitions

1987
Galerie Christophe Durr, Munich
Galerie Tanja Grunert, Cologne (catalogue)
Interim Art, London

1988
Galerie Tanja Grunert, Cologne
Galerie Ralph Wernicke, Stuttgart

1990
Galerie Metropol, Vienna

1991
Jay Gorney Modern Art, New York
(brochure)

Selected Bibliography

Beyer, Lucie and Karen Marta. "Why Cologne?" *Art in America*, December 1988, 45–51.

Bruderlin, Markus. "Thomas Locher, Galerie Metropol," *Artforum*, April 1991, 138.

Graw, Isabelle. "Thomas Locher, Galerie Durr," *Flash Art*, March/April 1990, 154.

_____. "Thomas Locher, Learn for Life," *Flash Art*, Summer 1990, 116–7.

Morgan, Stuart. "The World in Pieces," *Artscribe*, September/October 1987.

ANTONELLA PIEMONTESE

Born 1960, Naples, Italy
Lives and works in New York

Selected Individual Exhibitions

1989
Julian Pretto Gallery, New York
Special Projects 1990, P.S.1 Museum, The Institute for Contemporary Art, Long Island City

1991
Julian Pretto Gallery, New York

STEPHEN PRINA

Born 1954, Galesburg, Illinois
Lives and works in Los Angeles

Selected Individual Exhibitions

1988
Luhring Augustine Hodes, New York
University Art Museum, Santa Barbara

1989
Monochrome Painting, The Renaissance Society, University of Chicago (catalogue). Toured to Los Angeles Municipal Art Gallery; P.S.1. Museum, The Institute for Contemporary Art, Long Island City; Schedhalle, Zurich
Luhring Augustine Hetzler, Los Angeles
Galerie Crousel-Robelin, Paris

1990
Galerie Gisela Capitain, Cologne
Luhring Augustine, New York
Robbin Lockett Gallery, Chicago

1991
Galerie Peter Pakesch, Vienna
Galerie Max Hetzler, Cologne
Galerie Fricke, Düsseldorf

Selected Bibliography

Brougher, Nora Halpern. "Stephen Prina," *Flash Art*, November/December 1989, 144.

Cotter, Holland. "Eight Artists Interviewed," *Art in America*, May 1987, 162–79.

Fehlau, Fred. "Tim Ebner, John L. Grahm, Stephen Prina, Christopher Williams," *Flash Art*, November/December 1987, 108–9.

Palmer, Laurie. "Stephen Prina, The Renaissance Society, Chicago," *Artforum*, September 1989, 151–2.

Prina, Stephen and Christopher Williams. "The Construction and Maintenance of Our Enemies," *New Observations*, no. 44, 1987.

Rimanelli, David. "Stephen Prina, Luhring Augustine Gallery, *Artforum*, Summer 1990, 165–6.

Selwyn, Marc. "New Art L.A." *Flash Art*, Summer 1988, 109–15.

Steffen, Barbara. "Los Angeles: Something New in the West," *Artscribe*, November/December 1989, 9–11.

Woodard, Josef. "Playing with Information," *Artweek*, 26 November 1988, 5.

RICHARD PRINCE

Born 1949, Panama Canal Zone
Lives and works in New York

Selected Individual Exhibitions

1980
Artists Space, New York
CEPA, Buffalo

1981
Metro Pictures, New York
Richard Kuhlenschmidt Gallery, Los Angeles

1983
Le Nouveau Musée, Lyon
Institute of Contemporary Art, London

1984
Feature Gallery, Chicago
Baskerville + Watson, New York

1987
Daniel Weinberg, Los Angeles

1988
Centre National d'Art Contemporain de Grenoble (catalogue)
Barbara Gladstone Gallery, New York

Tell Me Everything, Spectacolor Lightboard sponsored by the Public Art Fund, Inc., 1 Times Square, New York

1989
Spiritual America, IVAM, Centro del Carme, Valencia (catalogue)

Selected Bibliography

Halley, Peter. "Richard Prince Interviewed," *ZG*, Spring 1984, 5–6.

Linker, Kate. "On Richard Prince's Photographs," *Arts Magazine*, November 1982, 120–2.

Morgan, Stuart. "Boyfriends, Girlfriends: Richard Prince's Alternative Bondings," *Artscribe*, March/April 1991, 44–5.

Prince, Richard. "Bringing It All Back Home," *Art in America*, September 1988, 29–33.

Rian, Jeffrey. "Social Science Fiction: An Interview with Richard Prince," *Art in America*, March 1987, 86–95.

Rimanelli, David. "Richard Prince," *Artforum*, February 1990, 134–5.

Saltz, Jerry. "Sleight/Slight of Hand: Richard Prince's *What a Business*, 1988," *Arts Magazine*, January 1990, 13.

Salvioni, Daniela. "On Richard Prince," *Flash Art*, October 1988, 88–9.

BUZZ SPECTOR

Born 1948, Chicago
Lives and works in Los Angeles

Selected Individual Exhibitions

1979
Roy Boyd Gallery, Chicago

1985
Bookworks, installation, Washington Project for the Arts, Washington, D.C.

1987
Installation, Randolph Street Gallery, Chicago

1988
The Art Institute of Chicago

1989
Center for the Visual Arts Gallery, Illinois State University, Normal
Roy Boyd Gallery, Santa Monica and Chicago

1990
Buzz Spector: New California Artist XXVII, Newport Harbor Art Museum, Newport Beach (catalogue)

1991
Corcoran Gallery of Art, Washington, D.C. (brochure)
Cool Fashion Room, installation, The Mattress Factory, Pittsburgh

Selected Bibliography

Anderson, Michael. "Buzz Spector," *Art Issues*, September/October 1989, 25.

Benezra, Neal. *Buzz Spector: The Library of Babel and Other Works* (exhibition catalogue). Chicago: Art Institute of Chicago, 1988.

Gardner, Colin. "Buzz Spector, Newport Harbor Art Museum," *Artforum*, Summer 1990, 173–4.

Graham, Dan. "Signs," *Artforum*, April 1981, 38.

Knight, Christopher. "An Open Book: Spector Exhibit in Newport," *Los Angeles Times*, 27 January 1990, F6,11.

Leffingwell, Edward. *Focus: Systems* (exhibition brochure). Los Angeles: Municipal Art Gallery, 1990.

Lyon, Christopher. "Buzz Spector: The Reading Room at Roy Boyd," *Images & Issues*, September/October 1982, 70–1.

Pagel, David. "Review, Roy Boyd Gallery, Santa Monica," *Arts Magazine*, September 1989, 81.

LAWRENCE WEINER

Born 1942, Bronx, New York
Lives and works in New York

Selected Individual Exhibitions

1964
Seth Siegelaub Gallery, New York

1970
Art & Project Gallery, Amsterdam (book:
ART AND PROJECT/LAWRENCE WEINER)
An Exhibition, Zentrum fur Aktuelle Kunst,
Aachen (catalogue)

1971
Leo Castelli Gallery, New York (book:
AFFECTED AND/OR EFFECTED)

1972
Westfälischer Kunstverein, Münster
(catalogue)

1976
Stedelijk Van Abbemuseum, Eindhoven
(catalogue)

1977
Coming and Going/Remaining Within the
Context of Put and Placement, Centre d'Art
Contemporain, Geneva (book: COMING
AND GOING)

1978
inK, Halle für Internationale Neue Kunst,
Zurich

1981
Special Projects Exhibition, P.S.1., Institute
for Art and Urban Resources, Long Island
City

1983
Works and Reconstructions, Kunsthalle,
Bern (catalogue)

1985
Lawrence Weiner: Sculpture, ARC Musée
d'Art Moderne de la Ville de Paris

1986
Water Under the Bridge, Leo Castelli,
142 Greene Street, New York

1988
Works From the Beginning of the Sixties
Toward the End of the Eighties, Stedelijk
Museum, Amsterdam (catalogue)

1989
Here, There, and Everywhere, Marian
Goodman Gallery, New York
Stuart Regen Gallery (inaugural exhibition),
Los Angeles

1990
WORKS series, Hirshhorn Museum and
Sculpture Garden, Washington, D.C.
(brochure)

1991–1992
Displacement, Dia Center for the Arts, New
York (brochure)

Selected Bibliography

Buchloh, Benjamin H.D., ed. Posters,
November 1965–April 1986, Lawrence
Weiner. Halifax: Press of Nova Scotia
College of Art and Design and Toronto: Art
Metropole, 1986.

Burnham, Jack. "Alice's Head: Reflections
on Conceptual Art," Artforum, February
1970, 37–43.

Cameron, Eric. "Lawrence Weiner: The
Books," Studio International, January 1974,
2–8.

Gardner, Colin. "The Space Between
Words: Lawrence Weiner," Artforum,
November 1990, 156–60.

Gustinet, Barthomeu Mari. Lawrence
Weiner: Show and Tell. New York: Delano
Grenidge Editions and Lyon: Le Nouveau
Musée, 1992.

Heinemann, Susan. "Lawrence Weiner:
Given the Concept," Artforum, March 1975,
36–7.

Lippard, Lucy R. "Art Within the Arctic
Circles," Hudson Review, February 1970,
665–74.

Rose, Arthur. "Four Interviews," Arts
Magazine, February 1969, 22–3.

Rose, Arthur R. "The Return of Arthur R.
Rose," Arts Magazine, February 1989, 50.

Weiner, Lawrence. Works. Hamburg: Anatol
AV und Filmproduktion, 1977.

CHRISTOPHER WILLIAMS

Born 1956, Los Angeles
Lives and works in Los Angeles

Selected Individual Exhibitions

1982
Source, The Photographic Archive, John F.
Kennedy Library. . ., Jancar/Kuhlenschmidt
Gallery, Los Angeles

1985
Selections from ADWEEK: Western
Advertising News, Vol. XXXIV, No. 20, April
20, 1984, Programmed with Herbert Gold,
Beyond Baroque Literary Arts Center,
Venice, California

1989
Shedhalle, Zurich
Galerie Crousel-Robelin/BAMA, Paris
Luhring Augustine Gallery, New York

1990
Luhring Augustine Hetzler, Santa Monica

1991
Bouquet, Galerie Max Hetzler, Cologne
(book)
Galerie Crousel-Robelin/BAMA, Paris

Selected Bibliography

Caley, Shaun. "A Forest of Signs: One is
Ushered into a Wonderland of Banality,"
Flash Art, November/December 1989, 134.

Fehlau, Fred. "Tim Ebner, John L. Grahm,
Stephen Prina, Christopher Williams," Flash
Art, November/December, 1987, 108–9.

Gardner, Colin. "Stephen Prina and
Christopher Williams," Artforum,
December 1987. 125–6.

Gookin, Kirby. "Christopher Williams at
Luhring Augustine Gallery," Artforum,
September 1989, 142.

Prina, Stephen and Christopher Williams,
"The Construction and Maintenance of Our
Enemies," New Observations, 44, 1987.

Rorimer, Anne. 74th American Exhibition,
The Art Institute of Chicago. Chicago: The
Art Institute of Chicago, 1982, 3–10, 47.

Solomon-Godeau, Abigail. "Living with
Contradictions: Critical Practices in the Age
of Supply -Side Aesthetics," Screen, 1987,
2–22.

Weissman, Benjamin. "Christopher
Williams' Dark Green Thumb," Artforum,
March 1990, 132–6.

Williams, Christopher. Angola to Vietnam
(artist's book). Ghent: Imschoot, Uitgevers
for IC, 1987.

University Art Museum

Marla C. Berns, *Director*
Phyllis Plous, *Curator of Twentieth Century Art*
Sandra Rushing, *Registrar*
Paul Prince, *Exhibitions Designer*
Corinne Gillet-Horowitz, *Curator of Education*
Julia Osterling, *Curatorial Assistant*
Sharon Major, *Public Relations*
Rollin Fortier, *Preparator*
Judy McKee, *Administrative Assistant*
Gary Todd, *Secretary*

Photography Credits

Jürgen Hilmer – pp. 16, 25, 43, 45

Wayne McCall – pp. 12, 13, 14, 15, 17, 18, 27, 35, 37, 39, 47, 49, 51, 53, 55, 59, 64, 66, 70, 77, 79, 82, 85

Douglas M. Parker – pp. 33, 60